# IMAGES
## of America
# MUNSTER
## INDIANA

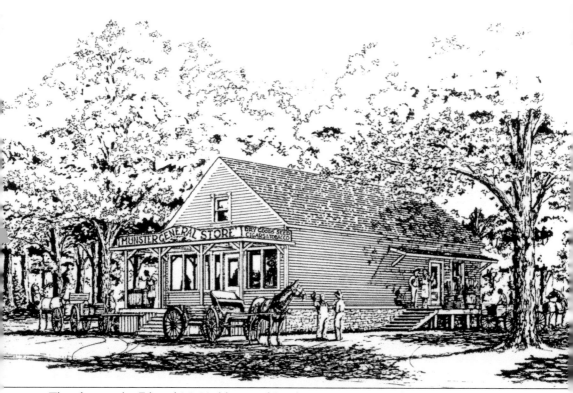

This drawing by Edward M. Verklan is of Jacob Munster's General Store once located along Ridge Road just east of Calumet Avenue on the north side of the street. The area surrounding this store became known as Munster primarily due to the fact that the store was the location of a contracted U.S. Postal Station for the distribution of area-residents' mail. In June of 1907, a referendum on incorporating the area known as Munster into a town was approved with a vote of 76 residents for incorporation and 28 residents against incorporation. The referendum voting was supervised by Gerbrand Kooy, Jacob Munster, and Charles E. Stallbohm acting as election inspectors. Then on July 1, 1907, the Lake County Board of Commissioners, basing their decision on the residents vote and paperwork prepared by Hammond attorney L.T. Meyer, agreed to recognize an area of 4,736 acres or 7.5 square miles as the newly incorporated Town of Munster. (Image courtesy of the Munster Historical Society.)

IMAGES of America

MUNSTER
INDIANA

Edward N. Hmurovic

Copyright © 2003 by Edward N. Hmurovic
ISBN 978-0-7385-2336-1

Published by Arcadia Publishing
Charleston, South Carolina

Printed in the United States of America

Library of Congress Catalog Card Number: 2003107014

For all general information contact Arcadia Publishing at:
Telephone 843-853-2070
Fax 843-853-0044
E-mail sales@arcadiapublishing.com
For customer service and orders:
Toll-Free 1-888-313-2665

Visit us on the Internet at www.arcadiapublishing.com

Author contact information:
Edward N. Hmurovic
1525 Poplar Lane
Munster, Indiana 46321

Enhmurovic@aol.com

Photo of the author. (Courtesy of the Hmurovic Family.)

# Contents

| | | |
|---|---|---|
| Acknowledgments | | 7 |
| Prologue | | 9 |
| 1. | Early Pioneers: 1840–1899 | 11 |
| 2. | Humble Beginnings: 1900–1919 | 31 |
| 3. | Difficult Times: 1920–1945 | 47 |
| 4. | Boom Years: 1946–1969 | 73 |
| 5. | Suburban Lifestyle: 1970–1989 | 101 |
| 6. | Commuter Community: 1990–Today | 111 |
| Epilogue | | 119 |
| Aerial Photographs | | 121 |
| References | | 128 |

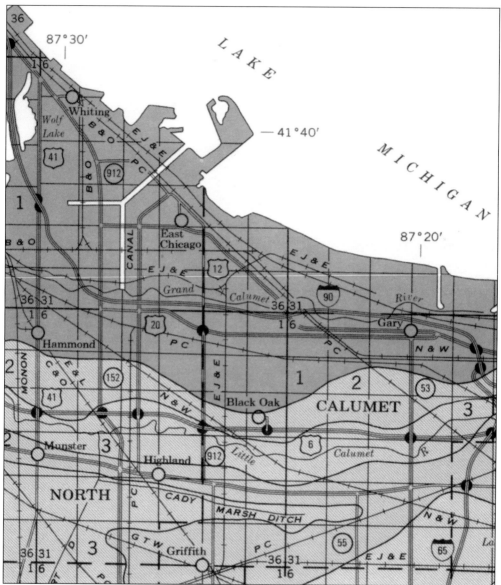

Based on the characteristics of the deposited soil, as noted in the map above, geologists speculate that approximately 14,000 years ago Lake Michigan's water level was almost 60 feet higher than it is today, with the southern shoreline being a sandy ridge running along parts of current-day U.S. 30. Nearly 1,000 years later, the lake level had receded almost 20 feet, creating a new sandy shoreline along what is now known as Ridge Road (which runs east and west through the center of the Town of Munster) and creating a great saturated marsh between the new shoreline and its predecessor to the south. Over the next 2,000 years, the lake continued to recede until the shoreline ran parallel to where today 169th Street is in the City of Hammond. In time, the Little Calumet River formed on the northern border of the area to become known as Munster, but its banks often overflowed, leaving the land between the former shoreline's sandy ridge and the newly formed river almost as damp as the land to the south of the ridge. Meanwhile, Lake Michigan's water level continued to slowly decrease until it reached its current location and height approximately 2,000 years ago. (Photo courtesy of the Munster Historical Society.)

# Acknowledgments

I would like to thank the wonderful people of the Munster Historical Society who are working to preserve the heritage that is the Town of Munster. Especially the Executive Director, Elaine Olson, and the past president, Cindy Watson, both of whom graciously welcomed my constant questions and endured my endless review of the Society's files. Also, to John and Sally Trent, Bob Cashman, Ken Schoon, Marie Hillegonds, Shirley Schmueser, and numerous others that kindly gave of their free time in researching the many mysteries of the town's history.

It is important to note that the efforts of the Munster Historical Society are forever ongoing and your support is always welcome. Fun and unique opportunities exist for individuals and corporations interested in providing financial assistance, performing volunteer research work, or doing volunteer restoration work. In addition, the society is always deeply interested in receiving photos, documents, or memorabilia relating to the history of the town, its community, and the businesses within the town. So please do not hesitate to contact the society at 1005 Ridge Road, Munster, Indiana, 46321.

I would also like to extend a special "Thanks," to Frank Darrington and the team at Galaxy Arts in Munster. Through their expertise, many of the old historic photographs used to create this book were restored to their original luster and preserved.

Realizing of course, that a book of this nature is prone to errors, I sincerely apologize for those that exist. I would welcome all comments you might have regarding the content, omission of content, or suggestions for future improvements. My address may be found on page four.

Finally, it has been my great pleasure to learn about the many pioneers, politicians, business people, and community activists that helped to build the character of the Town of Munster. It is in their honor that I am privileged to donate any financial gains I might otherwise have received from the sale of this book to the Munster Historical Society.

In closing, I would like to thank my family for supporting me throughout all my life's adventures, including the creation of this book. Especially my wife, Kathy, whose loving smiles and laughter brightens my every day. My children, Jillian and Danny, whose loving and adventurous nature bring me constant joy. Also my grandparents, Joseph and Susan Hmurovic, and John and Deodata Fadda, for having the courage to brave the many challenges they faced in making a new home in America. And finally, my parents, Joseph F. and Maria C. Hmurovic for introducing me to God and giving me the values that guide my life on a daily basis.

I sincerely hope you enjoy the book!

Ed Hmurovic

This Indian Tomahawk was collected by John Haimbaugh, along Greenwood Avenue south of Ridge Road. (Photo courtesy of the Munster Historical Society.)

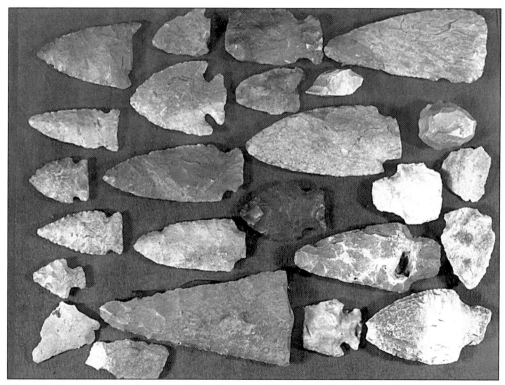
These Indian Arrowheads were collected by Neil Tanis, south of Ridge Road near Calumet Avenue. (Photo courtesy of the Munster Historical Society.)

# Prologue

The earliest known inhabitants of the area were the Potawatomi Indians. Although a village did not exist within what was to become the Munster town boundaries, the trail along the dry sandy ridge now known as Ridge Road was well traveled by the tribe. In the late 1600s and early 1700s, French explorers, priests, and trappers traveled throughout the area, which by then was considered a French Territory. However, in the 1760s, the British arrived and claimed the lands occupied by the Potawatomi. Twenty years later, George Rogers Clark overran the British to claim the territory for America. Soon thereafter, settlers began arriving to take advantage of the fertile farm land, while the resident Indians were being driven from their encampments. After the War of 1812, Indiana joined the Union and the Potawatomi became dependents of the Federal Government. Starting in 1828, treaties were written that transferred legal possession of the Indian's land to the Federal Government in return for reservation land in Oklahoma. While the Indians were being relocated to their new home in Oklahoma, the State of Indiana became the eventual owner of what would become Lake County, Indiana.

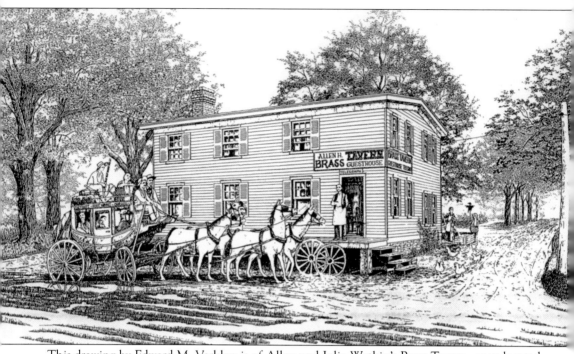

This drawing by Edward M. Verklan is of Allen and Julia Watkin's Brass Tavern, once located along Ridge Road just east of Columbia Avenue on the south side of the street. It was established in 1845 when the Brass' purchased it from David Gibson, who had operated it as Gibson's Inn from 1837 until 1845. (Gibson's Inn is the first building known to have been erected in the area later mapped as the Town of Munster). It was rebuilt by Allen Brass into a two-story structure resting on a limestone foundation with a porch the height of a wagon's step. It contained six boarding rooms upstairs, a bar, and a dining area for patrons downstairs. The Brass' themselves lived in a rear bedroom adjacent to the kitchen in the downstairs or first floor level. (Drawing courtesy of the Munster Historical Society.)

# One

# EARLY PIONEERS

# 1840–1899

As the Indian population began to dwindle, the number of settlers began to rise. The first notable settler, Joseph Bailly, a French-American, arrived in Lake County, Indiana, around 1822 and established a settlement near Fort Petit. This settlement, located just east of where Gary is today, was named Baillytown. Other settlements began to slowly develop, mostly along the old Indian trails that were now being used as routes to carry people, supplies, crops, and information to and from locations such as Fort Dearborn (Chicago), Fort Wayne, and Fort Petit (Gary). Farmers, traveling these routes via stagecoach, often settled on fertile land discovered during their journey. Officially considered squatters, most farmers formally purchased the land they had settled on during the March 19, 1839 land sale conducted by the State of Indiana. Initially purchased by the state in 1832 and surveyed in 1834, the land sale transferred formal ownership of most of Lake County, Indiana into the hands of either the land's settlers or investors speculating on the future value of the land. By late 1839, a significant number of farmers, shopkeepers, and millers had settled in the area around Crown Point and a county government had been formed. For the future Town of Munster, the Old Pike, as Ridge Road was then called, was the main route through an area that contained the wetlands of the Cady Marsh to the south and the often flooded lands of the Little Calumet River to the north. But that narrow, rutted, stump filled trail did have a way station for weary travelers to rest. That way station was called the Gibson's Inn and it was located at the intersection of the Old Pike and the Old Highway. The Old Highway, as Columbia Avenue was then called, was a small local trail leading to Chicago that went no further south than the Old Pike. A foot path did run from the southern edge of the Gibson's property south towards the Sauk Trail, intersecting with it in what is now the Town of Dyer.

By the early 1850s, the railroads where bringing waves of hopeful immigrants to the Chicago area, including many to Whiting's Crossing, Tolleston, and Hessville, which was located in Lake County. Included in this migration were a number of Dutch-Americans, many of whom settled in Low Prairie, which is now known as South Holland, Illinois. In 1853, a Dutch immigrant by the name of Gerritt Eenigenburg purchased 160 acres of fertile land in Oak Glen, now known as Lansing, for less than a dollar an acre. Encouraged by Gerritt's success in America, additional Dutch settlers began arriving in the years following Gerritt's settlement. Although not numerous in their numbers, many Dutch settlers bought property along the Old Pike including some in the area now known as Munster. Their industrious nature and knowledge of farming wet lands would help the area prosper despite difficult conditions.

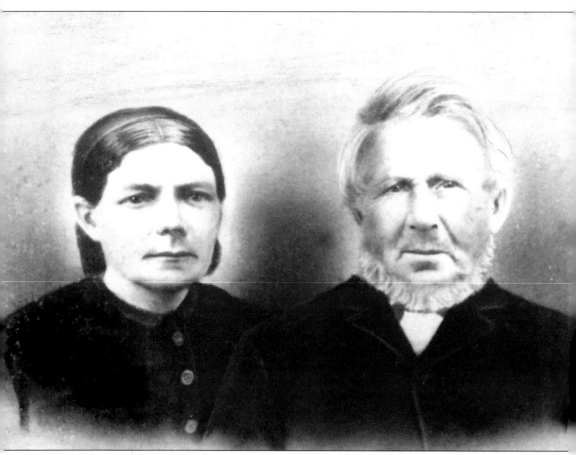

Peter Jabaay was the first Dutch immigrant to acquire land along the Old Pike (Ridge Road). In 1855, he purchased the acreage between where Jackson Street is today and the Illinois State line. Later that year he was joined by his father, Dingeman Jabaay, his mother, Gurtje Jabaay, and his brother, Arie Jabaay. Accompanying Arie was his wife, Sarah Decker Jabaay, and his son Foope. All had traveled from the village of Strijen, Netherlands and had crossed the Atlantic Ocean aboard a ship named the *Mississippi* which docked in New York City on July 5, 1855. Peter is shown above with wife Aartje VerSteeg Jabaay. (Photo courtesy of the Munster Historical Society.)

Also aboard the ocean liner *Mississippi* were Antonie Bouman, his wife Jannigje Bouman, as well as, his daughter, Nieltje Bouman Monster, her husband Eldert Monster, and Eldert's sons from a previous marriage; Jacob Monster age ten, Antonie Monster age seven, and Pieter Monster age four. The Monster family, along with the Bouman's who lived with them, soon bought acreage north of the Old Pike and just east of present day Calumet Avenue. Sometime after 1860, the family changed their name and began using the surname Munster. Pictured above is the Munsters' family home, once located along Ridge Road. (Photo courtesy the Munster Historical Society.)

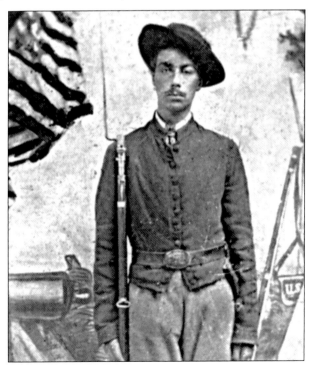

Quick to enlist, Jacob Munster (pictured here), the eldest son of Eldert Munster, joined the Union forces during the Civil War as a soldier in Company K of the Illinois Infantry. Accompanied by his friend Henry Schrage, he survived numerous battles as a member of General Sherman's troops and returned home to marry Hendrika Van Mynen in 1867. (Photo courtesy of the Munster Historical Society.)

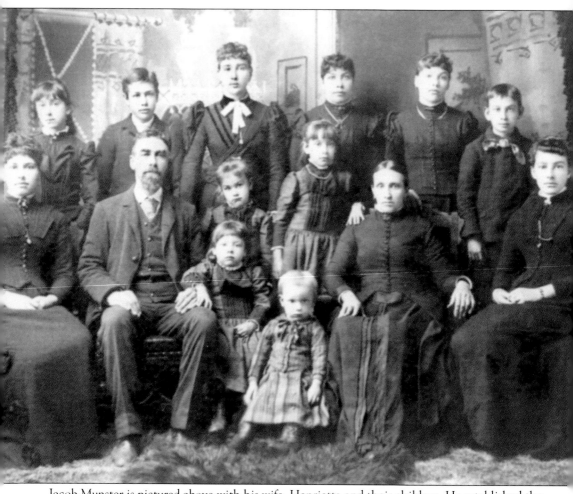
Jacob Munster is pictured above with his wife, Henrietta and their children. He established the Munster General Store, which was the location of the contracted U.S. Postal Station Office for which the Town of Munster was named. (Photo courtesy of the Munster Historical Society.)

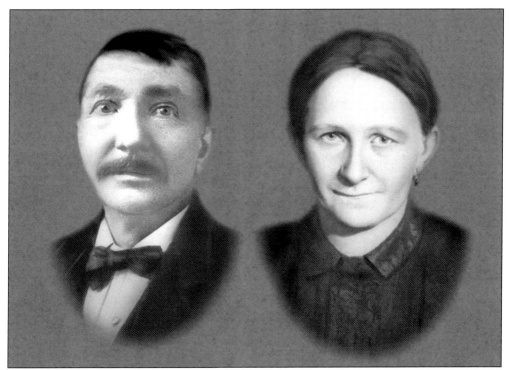

Other travelers to arrive in 1855 from the Netherlands and to settle along the Old Pike included Cornelius Klootwyk, his wife Lena Klootwyk, and their children, Peter Klootwyk, Nellie Klootwyk, and Cornelius Klootwyk. The Klootwyk's purchased acreage just west of present day Calumet Avenue. Shown above are Peter and his wife. (Photo courtesy of the Munster Historical Society.)

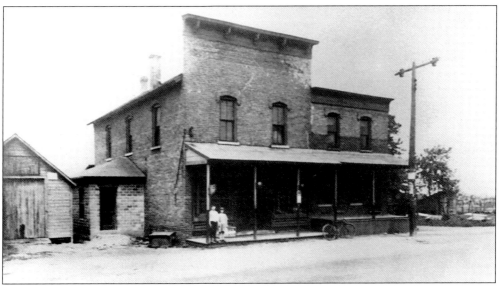

Pictured above is the Klootwyk General Store opened by Peter Klootwyk about 10 years after the Klootwyk families' arrival. It was located at what is now 619 Ridge Road. Peter Klootwyk's children, Peter and Mary, can be seen on the store's porch. (Photo courtesy of the Munster Historical Society.)

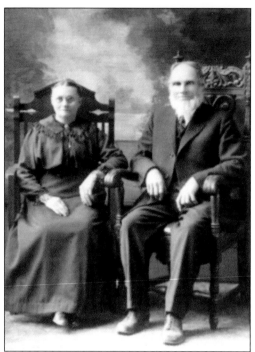

In 1857, Peter Kooy and his wife purchased a portion of Peter Jabaay's acreage to start a farm of their own. Gerbrand Kooy (Peter's son) is pictured above with his wife Mary Schoon Kooy. Gerbrand and his brothers, although farmers, were also the communities carpenters and were responsible for building many of the surrounding homes. Gerbrand himself also specialized in building coffins and violins. (Photo courtesy of the Munster Historical Society.)

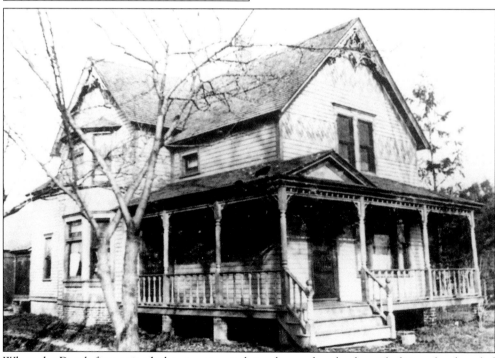

When the Dutch first arrived, they constructed simple wooden shacks with dirt and sod angled down from hand cut lumber walls to retain heat. However, as time passed, families grew larger and more prosperous. Clapboard framed farm houses and barns big enough to hold livestock and wagons began to appear. Gerbrand Kooy and his brothers constructed this home on the corner of Ridge Road and Jackson Street. (Photo is courtesy of the Munster Historical Society.)

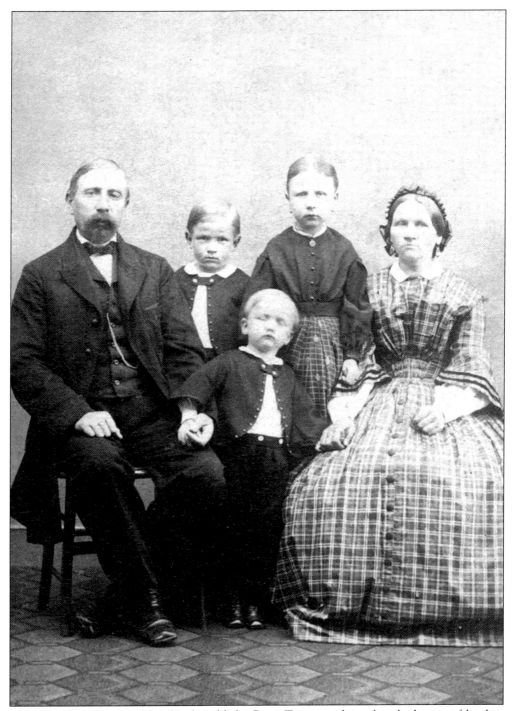

In 1864, Allen Brass and his family sold the Brass Tavern and two hundred acres of land to Johann and Wilhelmina Stallbaum (pictured above) for $5,000. The Stallbaums were German immigrants and later changed their surname to Stallbohm. The Stallbohms had three children, Charles Stallbohm, Caroline Stallbohm, and Wilhelmina Stallbohm. (Photo courtesy of the Munster Historical Society.)

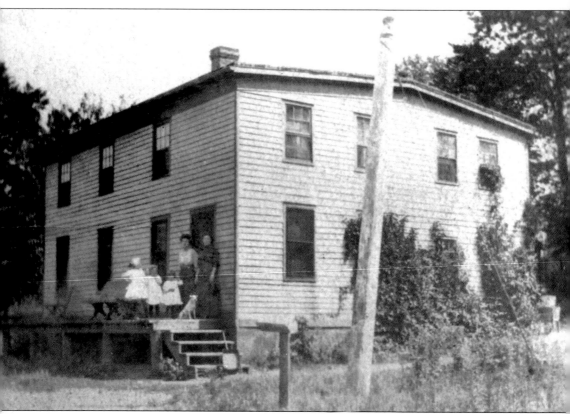

The Brass' tavern soon became known as Stallbohm's Inn. Currant wine was served fresh from Johann's press and Wilhelmina cooked homemade meals for guests using locally grown cabbages, potatoes, onions, cauliflower, and corn. The Stallbohm farm also grew hay and oats for use as livestock feed. In the 1890s, Johann Stallbohm, then in his seventies, closed what was then known as the "Green House" to boarders and travelers. He then converted the building into a large private residence used by members of his family. The photo above shows the building as it looked in the late 1890s and early 1900s. (Photo courtesy of the Munster Historical Society.)

Pigs and chickens were the primary source of meat locally and most farms had a few coops and pens including the Stallbohms. (Photo courtesy of the Munster Historical Society.)

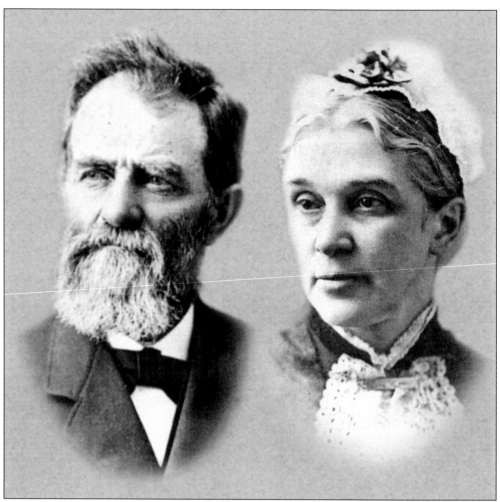

In 1870, wet land south of the Ridge was selling for approximately $5 an acre compared to dry farmland along the Ridge which sold for approximately $25 an acre. However, after years of purchasing acreage in the wetlands of the Cady Marsh just south of the Ridge, a land speculator named Aaron Hart began to change all that. Using oxen and local labor, Aaron Hart began to drain the wetlands by constructing ditches to flow the land-locked water to the rivers. An educated man, Aaron Hart (shown above with his wife) was not the first to use this technique, but by doing so, he became one of the area's first developers. Unfortunately, he was killed instantly on the morning of January 12, 1883 while at the bottom of a 10 foot deep ditch that collapsed while being cleared. His wife, Martha Dyer Hart, continued his work with the help of their children and successfully completed the project in the late 1890s. By then, an acre of dry land was easily selling for $100 and the Hart family, the owners of Hartsdale farm, owned over 8,000 acres. (Photo courtesy of the Munster Historical Society.)

During the last quarter of the 19th century, many new settlers had joined the growing farming community and over 125 men, women, and children now called the area home. American born families and immigrants alike continued to arrive in order to take advantage of the rich soil. New names appeared on local records such as, Bernard Swets, the Bakkers, Broertjes, DeBoers, Dekkers, Jansens, Kikkerts, Krooswyks, Schoons, and Vander Walls. Pictured here are Peter and Mary Schoon. (Photo courtesy of the Munster Historical Society.)

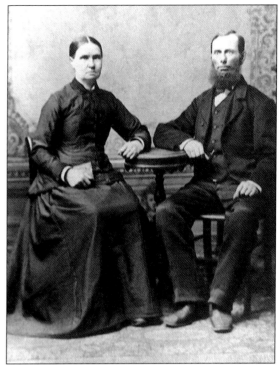

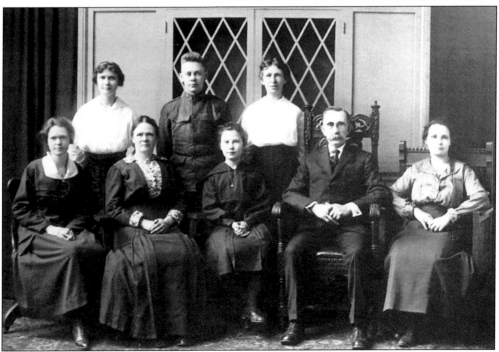

Shown above with his family is Cornelieus (C.P.) Schoon, son of Peter and Mary Schoon. Standing are Winnie Schoon, Peter Schoon, and Mary Schoon Tanis. Seated are Rose Schoon Kingman, Susan Schoon, Katharine Schoon Zybell, C.P. Schoon, and his wife, Hilda Jabaay Schoon. (Photo courtesy of the Munster Historical Society.)

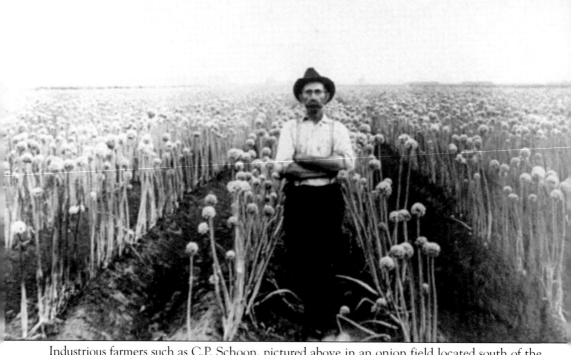

Industrious farmers such as C.P. Schoon, pictured above in an onion field located south of the Ridge and just west of where Calumet Avenue stands today, produced bumper crops for sale in local markets. Cabbage, corn, onions, potatoes, and many other crops were hauled by the area's farmers to be sold in Hammond, East Chicago, and even Chicago. (Photo courtesy of the Munster Historical Society.)

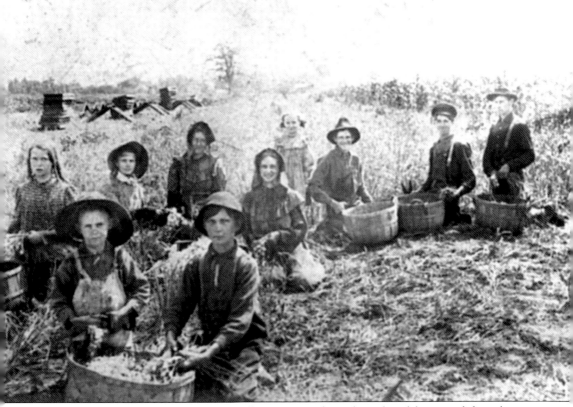

Onion sets, which are young onion seedlings, were often planted and harvested for sale to other farmers. Because mature ripe onions were in constant demand during the late 1800s and early 1900s, the growing of onion sets provided farmers with a good cash income early in the growing season. Pictured above is the harvesting of onion sets on the Jansen family farm. (Photo courtesy of the Munster Historical Society.)

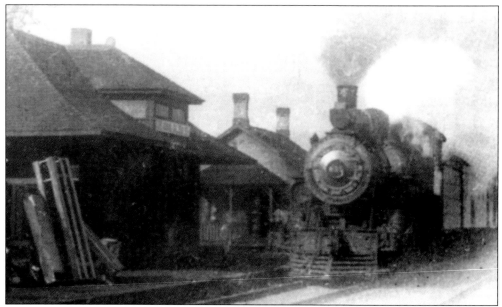

Trains traveling through the future Town of Munster in route to Chicago often stopped in Oak Glen. This photo shows a train pulling into the Grand Trunk Train Depot in Oak Glen which is now called Lansing. The Chicago and Grand Trunk Railroad is believed to have been established in Lake County in 1880. Early railroad maps referenced the area as Strathmore. (Photo courtesy of the Munster Historical Society.)

Garrett Jansen, pictured with his wife, Mary, and family, lived just west of the Louisville, New Albany, and Chicago Railroad tracks (which is believed to have been established in Lake County in 1882 and later became the Monon Railroad). Aside from being a farmer, he acted as the train's agent and sold tickets from his home's kitchen. (Photo courtesy of the Munster Historical Society.)

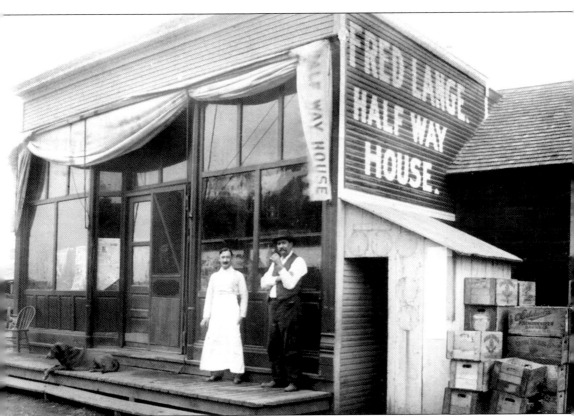

Fred Lange, pictured above, ran a halfway house and tavern near Maynard Junction. The junction, an important reference point on many railroad maps, represented the crossing of the Louisville, New Albany, and Chicago Railroad with the Chicago Grand Trunk Railroad. (Photo courtesy of the Munster Historical Society.)

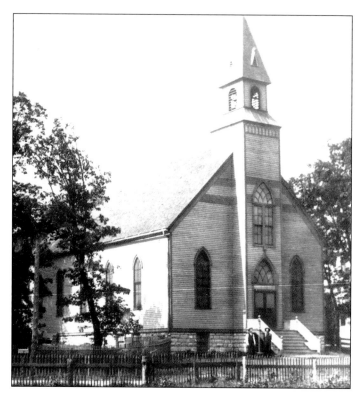

The Holland Christian Reformed Church located along Ridge Road was built in 1900 at a cost of $3,400. It was not the first church building located on the site for the Dutch and American worshippers. In 1875, the congregation had built a 24-foot by 36-foot frame building with a bell tower for $429.73. (Photo courtesy of the Munster Historical Society.)

In 1879, Reverend Dirk Mollema became the first minister of the True Holland Christian Reformed Church. In 1885, the church changed its name to the Holland Christian Reformed Church. The church's strong fundamentalist values and community presence played a key role in developing the character of the future Town of Munster. (Photo courtesy of the Munster Historical Society.)

Built in the mid-1800s and remodeled repeatedly, this house, now known as the Benoit House, is located on the southeast corner of Ridge Road and Walnut Drive. Originally owned as a residence by Chauncey Wilson, the area's first teacher and Justice of the Peace, the structure was used to host the first classes for the area's children. After Chauncey left to join the army during the Civil War, his wife Julia Ann assumed his teaching duties. Unfortunately, Chauncey did not survive the war. Soon after, his daughter, Frances, took up teaching where her mother and father had begun. (Photo courtesy of the Munster Historical Society.)

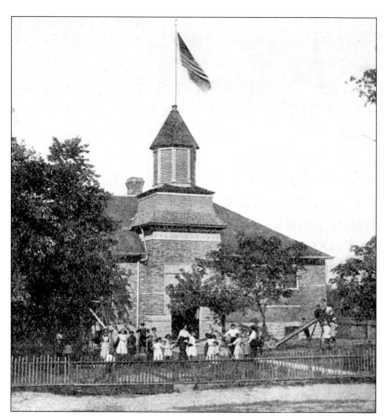

In 1852, the North Township trustees authorized the construction of the area's first official school. Built at a cost of $16, it was located on the southeast corner of where Greenwood and Ridge Road intersect today. A larger one room schoolhouse was built across the street in 1870. Finally, in 1875, a three room schoolhouse (shown here) was built on the corner of Ridge Road and Calumet Avenue on property purchased from Jacob Munster. (Photo courtesy of the Munster Historical Society.)

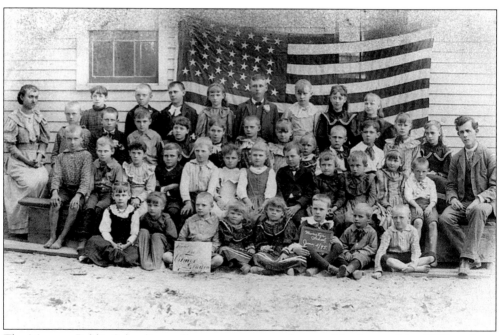

The Munster Public School's enrollment was very modest, as this photo of the 1895 students demonstrates. (Photo courtesy of the Munster Historical Society.)

As the population continued to increase, more homes were built to accommodate the new residents. Shown here are Vienna Vander Molen Rietveld and her children. They are standing in front of their home located along Ridge Road. (Photo courtesy of the Munster Historical Society.)

The Kirsch family is pictured here, standing in front of their new home located behind where the southeast corner of Ridge Road intersects with Calumet Avenue today. As the 19th century ended, many new residents could be found making their homes on the Ridge. (Photo courtesy of the Munster Society.)

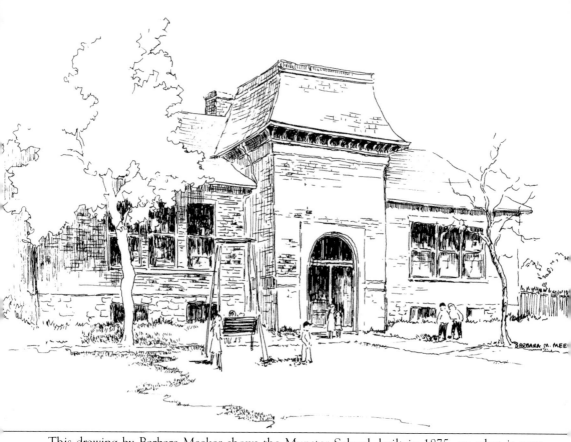

This drawing by Barbara Meeker shows the Munster School, built in 1875, on what is now the northeast corner of Ridge Road and Calumet Avenue. The land was originally purchased from Jacob Munster at a cost of $30. It later became Munster's first town hall in 1915. It was eventually demolished in 1920 and a new town hall was built in its place. (Drawing courtesy of Munster Historical Society.)

# *Two*

# HUMBLE BEGINNINGS

## 1900–1919

By 1905, the population along the ridge had reached approximately 400 men, women, and children, with the majority belonging to one of the fifty farming families (most of Dutch heritage) occupying the area. Sons and grandsons now farmed smaller plots of land inherited or bought from their families. Investors, speculating on the growing value of newly dried and fertile land, often leased their holdings to local farmers. The road along the ridge was still dirt with only an occasional scraping (to level the grade), rolling (to flatten snow), or summer oiling (to keep dust clouds from forming). A wooden plank bridge spanned the Hart Ditch to allow wagons easy access across, and wells were still located behind most homes for drawing water. The telegraph and U.S. mail service were still the only means of commercial communication, with the exception of the occasional *Lake County Times*. When most people wanted to send a package or letter to a local farmer, they would give it to a traveler or a postal carrier and ask them to "take it to Munster" referring to Jacob Munster's General Store and the location of the contract U.S. Postal Station. Access to both the party-line telephone and electrical service was still 10 years away for residents of the area. Root cellars were used for storing produce, and livestock was generally eaten fresh or dried. Shopping consisted mostly of a trip to one of the two local general stores, or for the hardier, a trip to one of Hammond's fashionable stores. Occasionally, a journey to Chicago would be made for a special purchase. Entertainment consisted mostly of a visit to a tavern (one or two existed locally) or the occasional church sponsored social event. Dances and musical activities often occurred in individuals homes or barns and quilting bees were frequently organized by the women. For the most part, the future Town of Munster was simply a small prosperous farming community filled with residents who had a hardworking Dutch heritage and deep Christian beliefs.

However, residents were watching as their neighbors to the north in the City of Hammond were experiencing extraordinary growth. Hammond's population was quickly approaching 20,000 and a significant number of newly established manufacturing companies were being built within the cities boundaries. With growth surging towards them, it became clear to many residents that the time had come to incorporate their community and establish a governing body to provide needed services, as well as encourage local development.

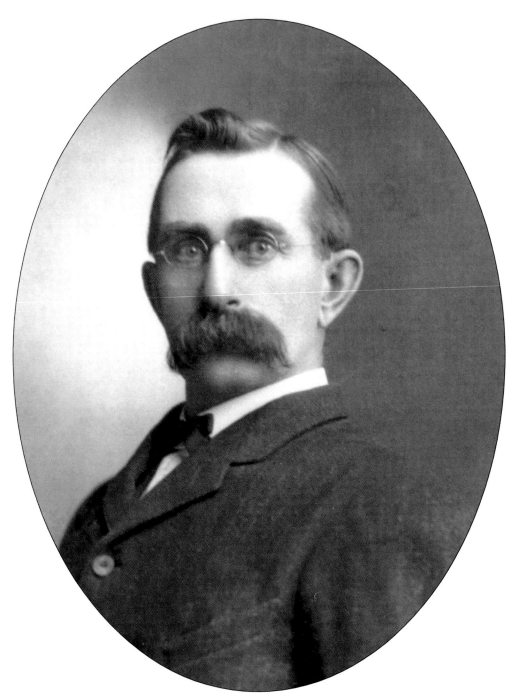

In early June of 1907, a public meeting was held to discuss the possible incorporation of the North Township area in which the local residents lived. C.P. Schoon (pictured above), a Republican and the North Township assessor from 1890 to 1905, led the group to agreement. It was decided that an election would be held on June 15th to allow those living in the community an opportunity to vote on a referendum to incorporate and create a governing body. (Photo courtesy of the Munster Historical Society.)

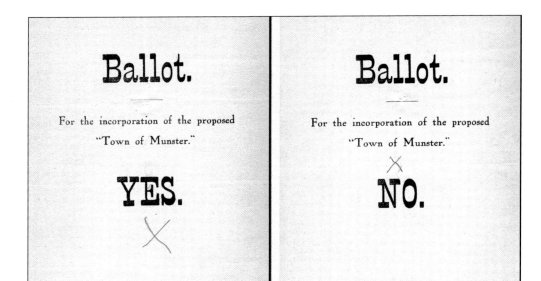

Election inspectors, Gerbrand Kooy, Jacob Munster, and Charles Stallbohm, supervised the local vote on incorporation held June 15, 1907. When the results were tallied, 76 residents had voted "yes" for incorporation and 28 had vote "no" against incorporation. The inspectors then contracted with Hammond attorney L.T. Meyer to prepare the articles of incorporation necessary for submission to the Lake County Board of Commissioners. On July 1st, 1907, the county commissioners declared the Town of Munster duly incorporated. (Photos courtesy of the Munster Historical Society.)

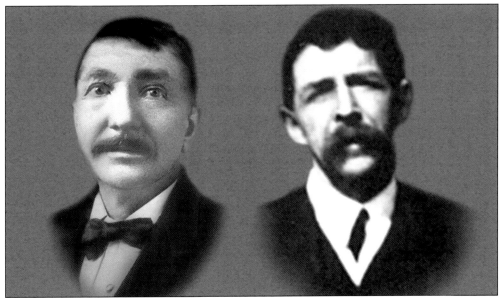

On July 31, 1907, an election was held to determine who would be the Town of Munster's first trustees and officers. Four wards had been established with Jacob Bakker elected first ward trustee, Peter Klootwyk (above left) elected second ward trustee, John DeVries (above right) elected third ward trustee, and Fred Lange elected fourth ward trustee. C.P. Schoon was elected town clerk and Garrett Jansen was elected town treasurer. Shortly thereafter, August Richter was appointed the town's first lawman at a salary of $60 a year. (Photos courtesy of the Munster Historical Society.)

Shortly after the town was incorporated, a land speculator, Lucius Fisher (pictured here), who owned close to 900 acres of land on the south and west side of town, began to raise concerns regarding property tax rates and the need to incorporate. The newly elected town officials rallied together to explain the advantages and agreed to levy only a modest tax rate (by 1920, Munster's tax rate was still only 28 cents per hundred dollars of valuation). Mr. Fisher happily agreed, and the town council, relieved to have avoided legal action, promptly named a street after him. (Photo courtesy of the Chicago Historical Society.)

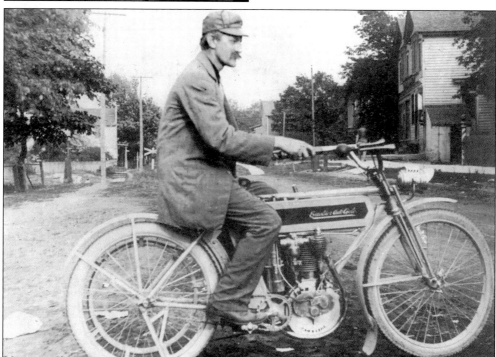

Due to the emerging popularity of automobile and motorcycle transportation, as well as the resulting number of accidents which occurred involving local livestock and farm machinery, the 1909 town council voted to define a speed limit of eight miles per hour for all vehicles traveling on Ridge Road. John Swart (pictured above), who owned a general store in neighboring Oak Glen (Lansing) and ran a grocery wagon servicing the residents of Munster, was often seen motoring along on Ridge Road on his Auto-Cycle. (Photo courtesy of the Munster Historical Society.)

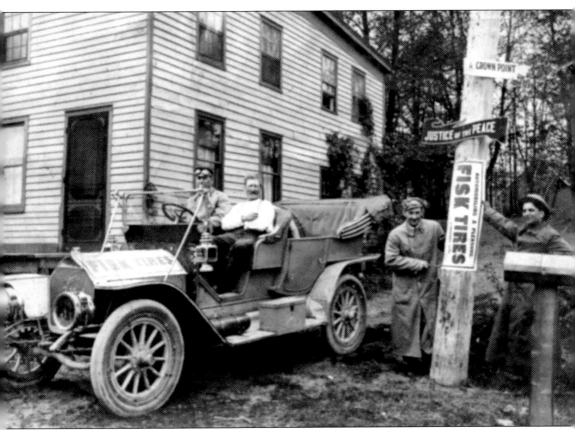

Since the arrival of the automobile, it had became apparent that road improvements needed to be made. The first major project undertaken by the new town council was rebuilding the Hart Ditch Bridge over Ridge Road. Shortly thereafter, Ridge Road was graded, widened, and a gravel surface coat was applied to support automobile traffic. In time, the road leading to Dyer, which at that time was the only southbound route connecting Ridge Road to Lincoln Highway, was also improved and portions of it were relocated to more easily accommodate motorized traffic. Jacob Kooy and Peter Klootwyk were the town's first residents to own automobiles. Hugo Kaske is shown above proudly seated in an expensive motorcar that stopped near his home (once the Stallbohm Inn). (Photo courtesy of the Munster Historical Society.)

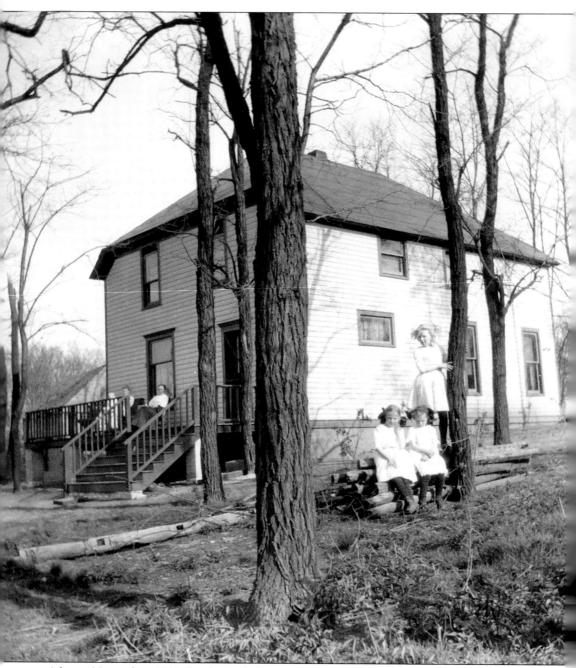
After a November 1909 fire burned down their residence, which at one time had been the Stallbohm Inn, this home was built for the Hugo Kaske family. Constructed on the southeast corner of Ridge Road and Columbia Avenue, it was set back away from the road and eventually became the property of Helen Kaske Bieker. Shown above are three of Hugo and Wilhelmina Stallbohm Kaske's children, Louise, Erma, and Helen. (Photo courtesy the Munster Historical Society.)

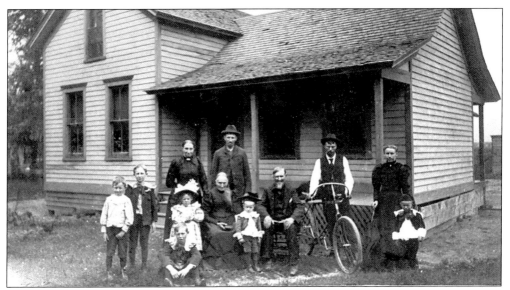

Children and grandchildren of the original settlers continued to make their homes and their livelihoods within the Town of Munster. Dingeman Jabaay and his wife Ida, along with their children, are pictured here with his parents, Arie and Gertrude Jabaay. Dingeman's grandfather was Peter Jabaay, the first Netherlander to settle in the area. Albert Flym and his wife Jennie, along with their son, Clarence, can be seen standing to the right in the photo above, as they visit the Dingeman Jabaay's at their home located on the northeast corner of Ridge Road and Hohman Avenue. (Photo courtesy of the Munster Historical Society.)

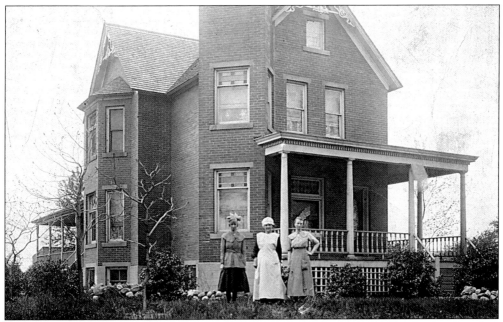

This brick home was built for Dirk and Dora Schoon and their family by the Kooy's who often did construction projects. Between 1862 and 1924 only 35 homes were constructed within the boundaries of the Town of Munster. Pictured above are Mary Schoon, Dora Schoon, and Jacoba Schoon. (Photo courtesy of the Munster Historical Society.)

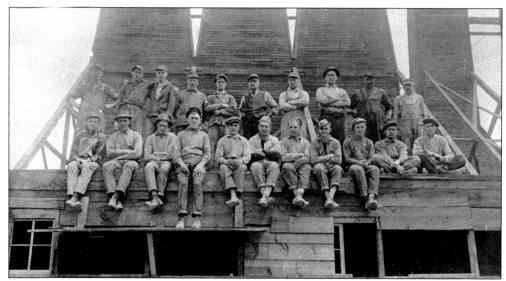

Starting in 1905, the National Brick Company established the Maynard Brick Yards, a clay mining and brick kilning operation, near the current intersection of 45th and Calumet Avenues. The high quality clay found under the soil was made into brick for use in the construction of buildings and roadways throughout the Chicago area. Often closed because of fluctuating demand, the plant operated using wood and coal to heat its kilns and employed many local farmers as part time laborers. (Photo courtesy of the Munster Historical Society.)

In 1906, the brick plant operated on 160 acres with 94 laborers and 42 skilled men. It was the town's only industrial plant and was a source of additional income for many local farmers. The 1800 degree kiln firing operation was converted to oil in the late 1920s. Shown above is Carl Dittrich at the Maynard Brick Yards. (Photo courtesy of the Munster Historical Society.)

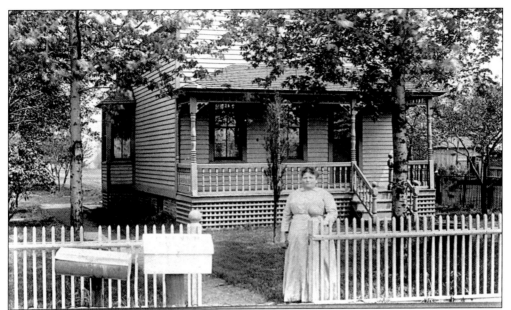

The *Lake County Times*, in a 1910 article by its editor, announced that "Munster is booming." By 1910, the town had 543 residents and approximately 60 to 70 families living and farming along the ridge. Pictured above is Johanna Jabaay Neven at her home on the corner of Ridge Road and Harrison Street (then called Neven Drive). (Photo courtesy of the Munster Historical Society.)

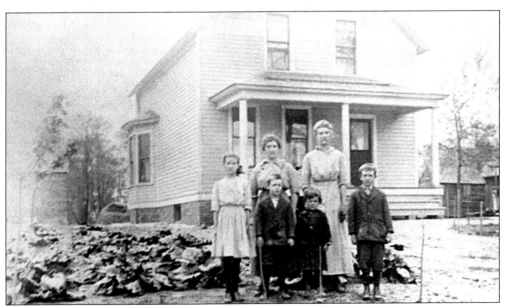

By 1915, homes such as this one, located at 1006 Ridge Road and owned by the DeMik family, had begun the process of modernization. Telephone service provided by the Chicago Telephone Company was made available to homeowners in the form of either a private line or a party line shared by up to four homes. Northern Indiana Gas and Electric lines began moving south from Hammond in the same year, and shortly thereafter street lamps began appearing on the town's roads. However, residents had to wait until 1927 for natural gas to be delivered via pipelines to their homes. (Photo courtesy of the Munster Historical Society.)

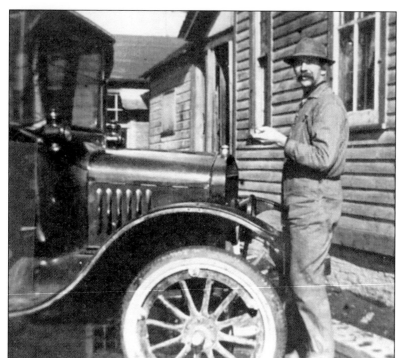

An avid outdoorsman, John DeVries (shown here), with his wife Dirkje Bos DeVries and their six children, lived on a homestead along the banks of the Little Calumet River just west of where Harrison Street is today. (Photo courtesy of the Munster Historical Society.)

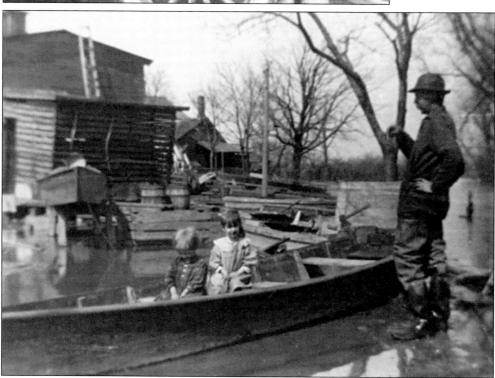

As seen in this 1920 photo of John DeVries and two of his children, the Little Calumet River often overflowed its banks and wrecked havoc on the homes of property owners living north of the ridge and south of the river. (Photo courtesy of the Munster Historical Society.)

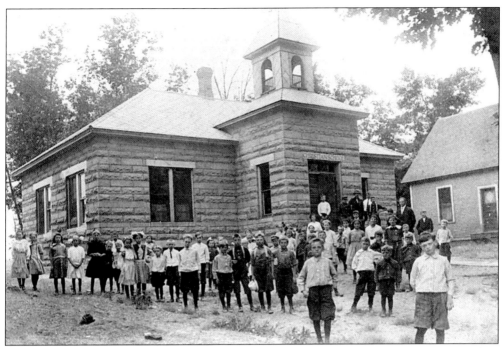

The Munster Christian School, shown above, which was built in 1907, was a four-room building located next to the Christian Reformed Church. With classes often being taught in Dutch, the school prospered, and in 1917, it had 124 students with 8 graduating. (Photo courtesy of the Munster Historical Society.)

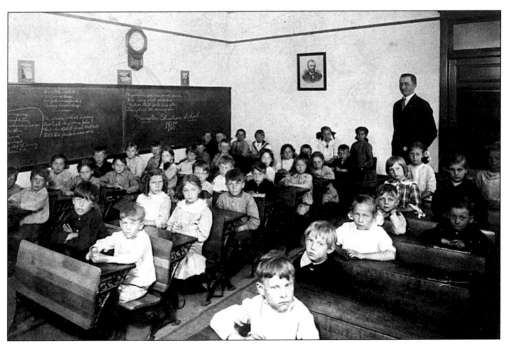

This 1915 class taught by Mr. John Tuls shows some of the students of the Munster Christian School. (Photo courtesy of the Munster Historical Society.)

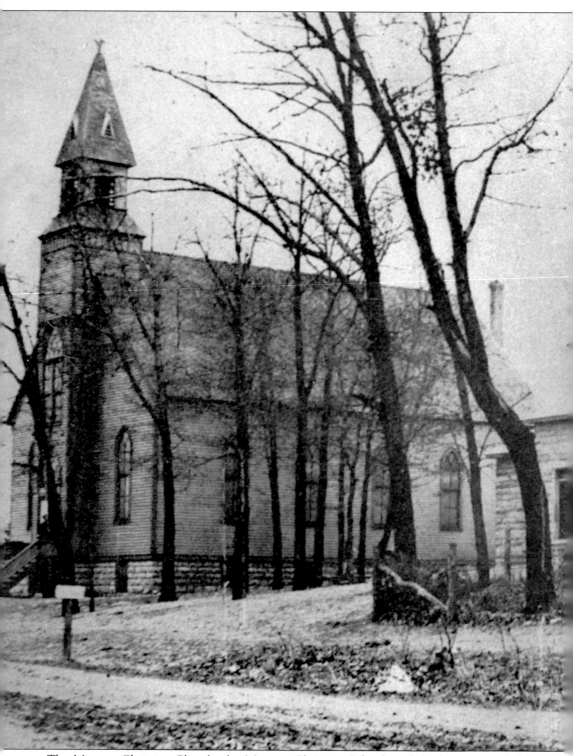
The Munster Christian Church, the Munster Christian School, and the home provided for the school's principal are shown in the photo above. Located along Ridge Road near where

Hohman Avenue is today, John Swart's grocery wagon can be seen tethered to a tree. (Photo courtesy of the Munster Historical Society.)

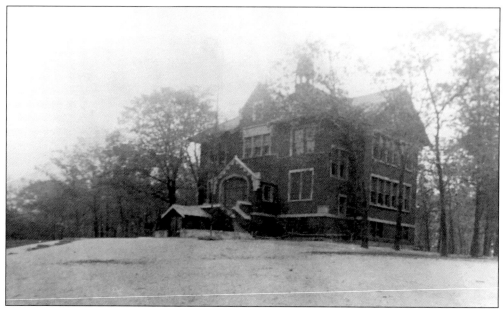

In November of 1908, the North township trustees transferred ownership of the school located at the corner of Calumet Avenue and Ridge Road to the newly appointed Munster School Board. Beginning in 1913, the school board began to make plans for the construction of a new Munster school to be located on ten acres of land just south of Ridge Road and to the west of Columbia Avenue. Completed in 1915 and shown above, it contained four classrooms, a library, and a small auditorium. (Photo courtesy of the Munster Historical Society.)

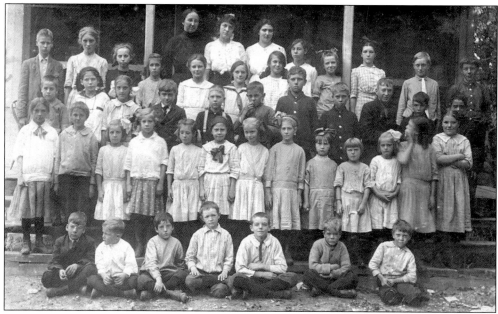

In 1915, the new Munster school taught grades one through eight with 40 school children in attendance. Only two students graduated that year. Although three children graduated in 1916, it took many more years before attendance exceeded 50 children. (Photo courtesy of the Munster Historical Society.)

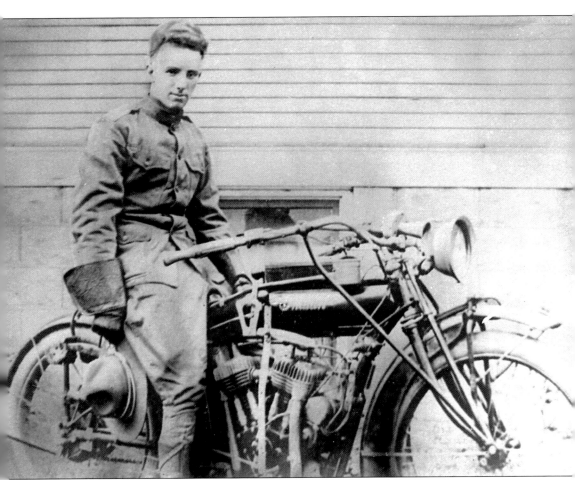

By 1919, Munster's population had grown to just over 600 residents. Young men such as James Munster DeYoung, shown above dressed in his World War I uniform and mounted on his Indian motorcycle, found themselves enjoying the experience of traveling beyond the next town. For most however, Munster remained a quiet and peaceful place to live. (Photo courtesy of the Munster Historical Society.)

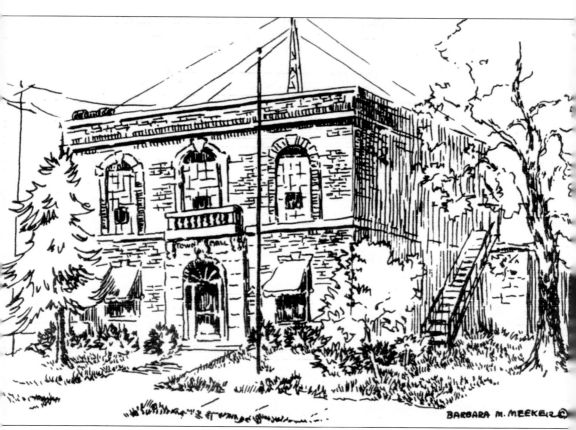

This drawing by Barbara Meeker is of the Munster Town Hall that was completed on May 31, 1921. It replaced the Munster School building, originally built in 1875, on what is now the northeast corner of Ridge Road and Calumet Avenue. The building was composed of an office area on the first floor, which was used to conduct town business, and a large public meeting room with an adjacent kitchen on the second floor. Many, if not all, of Munster's emerging community organizations found the second floor to be an inviting place to have meetings. (Drawing courtesy of Munster Historical Society.)

# *Three*
# DIFFICULT TIMES
## 1920–1945

The roaring twenties greeted Munster with the quiet operation of a speakeasy near the southwest corner of Ridge Road and Calumet Avenue. The weathered wood exterior hid the sophisticated and welcoming look of its functional interior. Poker, dice, and roulette games were available for those who whispered they were "friends of Nick" to the doorkeeper, and a small private back room was available to those with distinguished needs and fat pocketbooks. The *Lake County Times* called it "one of the finest gambling dens and gangster hangouts in Lake County."

The end of the war had signaled a period of jubilant optimism in America, and despite Munster's seemingly obscure location, many businesses were finding Munster an attractive place to locate. New businesses began to appear and passersby could now find everything from barber shops to gas stations next to the decades old farm stands. A new town hall was built, and vehicle traffic through town continued its steady growth. Employees of the steel mills and petroleum refineries, located along Lake Michigan, became interested in living in the quaint and clean surroundings of the Town of Munster. Big plans were under development for numerous commercial enterprises and residential subdivisions when the Great Depression hit. Dreams of larger homes on spacious lots in the fresh air of Munster quickly vanished for most would-be residents, but the image of Munster as a desirable place to live had been established.

For the farmers of the day, the Depression, although significant in other ways, was not devastating. They continued to feed their families, but cash was hard to come by and most resorted to bartering for items they could not grow. The local brickyard had gone dormant, and employment opportunities, which had always been available to those willing to travel to Hammond, now were non-existent. Between 1930 and 1935, the assessed property within the town's borders lost a little over a third of its value. Many residents had difficulty paying their taxes and even the town itself was looming on the edge of financial disaster until Peter Tanis, the town's treasurer, managed to secure the much needed funds to keep it operating.

In 1935, with the war looming and armament contracts for steel and petroleum driving local employment numbers upward, prosperity began to return to the Calumet region. Within time, the region's industrial facilities, now operating as the manufacturers of components deemed critical to the defense of the country, began to rapidly hire workers, many of whom needed housing. Many of the abandoned residential developments were quickly revived and home construction began again. Despite the fact that most housing construction in the U.S. ceased during World War II, the Town of Munster rapidly grew due to the need for housing and services for "war workers."

Having started with only 600 residents in 1920, mostly farmers, the Town of Munster had grown to more than 1,700 residents by 1940, with the vast majority of residents employed by the industries north of town. By the war's end, Munster had reached approximately 3,600 residents, and its days as a farm town were nearly over.

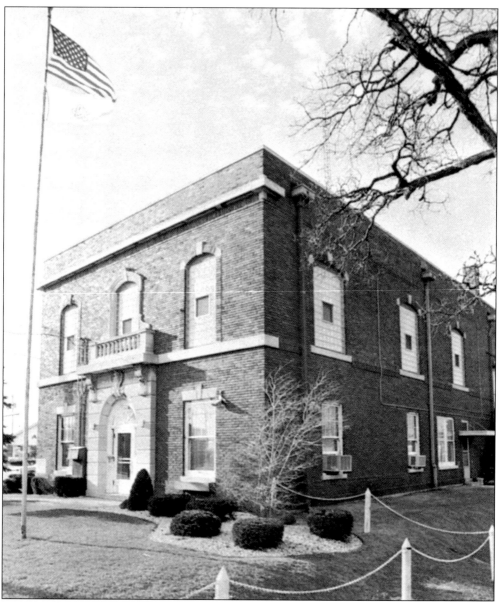

In 1920, the town's business was still being transacted in the 45 year old Munster School building that had become the temporary town hall when a new school was built in 1915. Despite numerous attempts, it wasn't until 1920 that the town trustees managed to find a demolition firm willing to tear the old building down without charging the town a fee. Shortly thereafter, the town trustees, acting as the general contractor, became heavily involved in the construction of the $30,000 two story structure (shown above). Used primarily for official town business, it also hosted community plays, traffic court, and numerous civic and social organizations in its large second floor meeting room. A modest single garage door to the rear of the building provided the fire department with entry to a space used to house their equipment. Dedicated on April 7, 1921, the building served the community well until 1982. (Photo courtesy of the Munster Historical Society.)

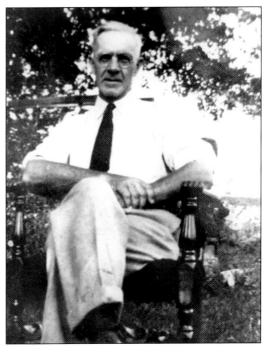

Leonard Brink (shown here) was Munster's first fire chief. Elected in 1925 by the newly formed Munster Volunteer Fire Department, he helped modernize the town's aging fire equipment. Faced with using only a wooden cart holding 300 feet of fire hose, which was towed by a volunteer's Model T Ford, he secured funding for the town's first fire truck. The 1926 Dodge pumper truck, purchased at a cost of $3,555, was then proudly stored in the rear of the new Town Hall. (Photo courtesy of the Munster Historical Society.)

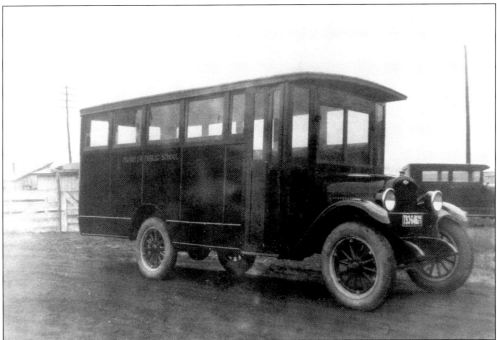

In 1921, the Indiana State Legislature passed a law requiring all children under the age of 16 to remain in school. Despite this public encouragement, the total number of students attending the Munster Public School hovered around 150 for most of the decade. The town did implement bus service, and by 1922, a school bus (shown above), with Luke DeBoer as its driver, was in service delivering the community's children safely to the public school. (Photo courtesy of the Munster Historical Society.)

A Parent Teacher Association was formed in 1922 by Mrs. Hugo Kaske (shown here) and 25 other parents. Their first item of business was to create a hot lunch program for the children. Lunches, costing only a few pennies, were served by volunteer moms to eager children. Much of the food served was grown locally and either donated or purchased by the PTA. (Photo courtesy of the Munster Historical Society.)

Despite a more or less flat enrollment, the Munster School continued to produce outstanding graduates who chose to continue their education even in the most difficult of times. Shown below is the graduating class of 1927. The back row includes Helen Jabaay, Harry Horton, Elizabeth Kirsch, John VanDerTuuk, and Susie Porte. The middle row includes Annabelle Munster, Miss Merle Stone, and Frances Gill. The front row includes Maurice Kraay and George McKee. (Photo courtesy of the Munster Historical Society.)

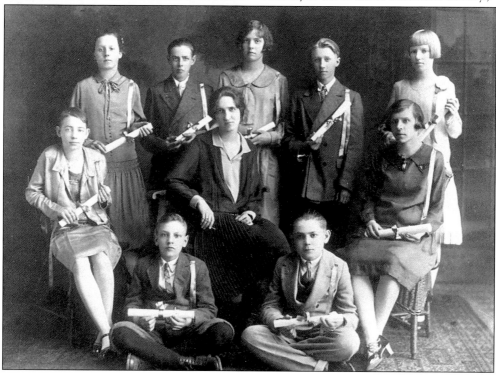

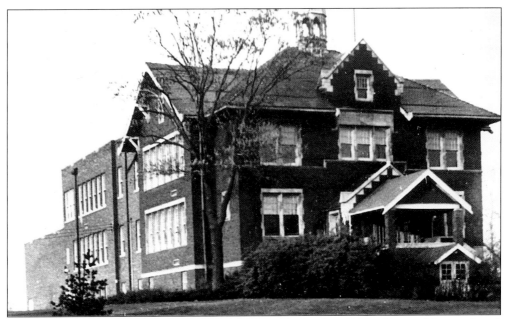

Acknowledging the need to educate children by grade level, a 1928 addition (shown above) was made to the Munster School. Once completed, the school contained a total of eight classrooms in which grades one through eight were taught individually. At the same time, a gymnasium was constructed at the rear of the building to encourage student athletics. (Photo courtesy of the Munster Historical Society.)

Many home builders, encouraged by the newly improved Hohman Avenue Bridge leading to Hammond, began to sell homes along Hohman Avenue north of Ridge Road. Homes, such as the one shown above, were carefully built as "better-than-average" with many elegant features not normally found in other homes built during the same time period. (Photo courtesy of the Munster Historical Society.)

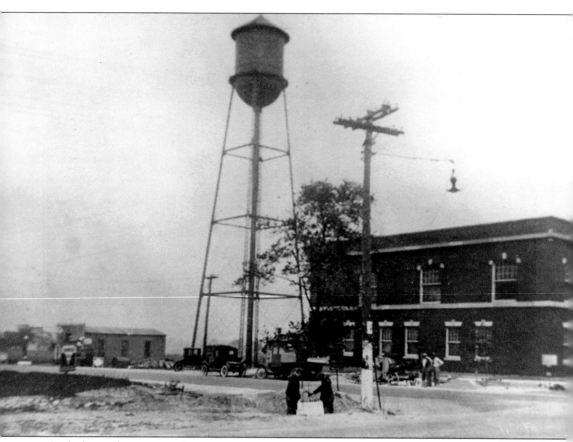

Aside from other issues, it became apparent to those governing the town that a need existed for a stable community wide water system. Formed in 1923 as an independent entity, the Munster Water Company, with a lucrative town contract and flush from cash derived by the sale of its stock, began to build the necessary infrastructure needed to supply water to the town's residents. The first community well, drilled into a water vein located behind the town hall and its 35,000 gallon storage tank (shown above), began to provide water to local residents in 1924. However, by 1926 the town decided to purchase the Munster Water Company and create a municipal water system. Unfortunately, ownership by the town did not remedy the frequent shortages and peculiar tasting water for many years to come. The water tank was demolished in 1962. (Photo courtesy of the Munster Historical Society.)

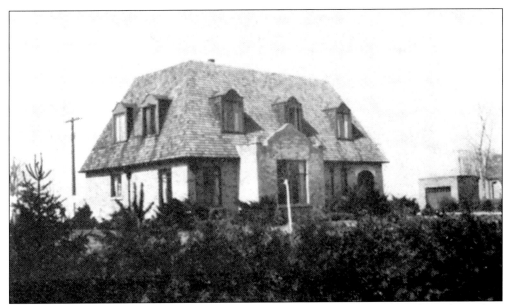

With the automobile's extended reach making it easier and easier to travel north to their workplaces, buyers poured in to look at lots available from reality companies selling land between Ridge Road and the Little Calumet River. An astounding 113 homes, including the one shown above, which was constructed for D.T. Steffan, were built in Munster between 1925 and 1929. (Photo courtesy of the Munster Historical Society.)

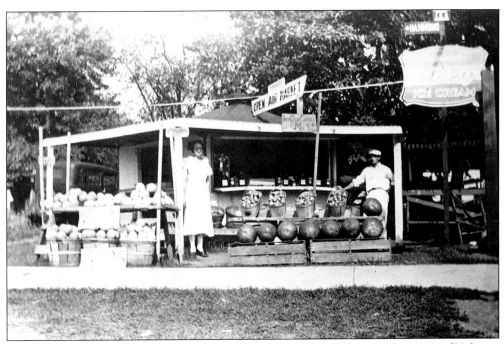

For years, farm stands, like this one owned by Gert and Martin Boender near the corner of Hohman Avenue and Ridge Road, provided local produce to those passing by. Cantaloupes, raised locally, could be purchased for a nickel, and bananas, imported from Chicago distributors, sold for a hefty 17¢ for a 3 lb. bundle. (Photo courtesy of the Munster Historical Society.)

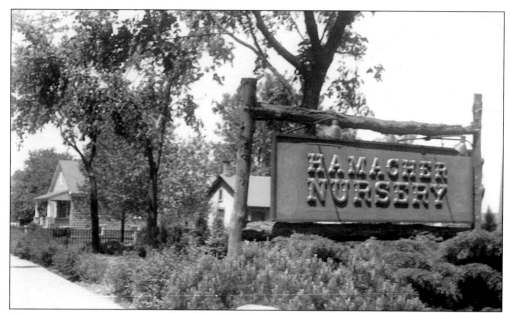

With the advent of new growth within the town's borders, local farm stands began to emerge as agricultural nurseries and retail centers. Selling flowers, bulbs, trees, bushes, and garden plantings, early entrepreneurs such as Walter "Bussie" Mills, who ran a large retail operation just east of Calumet Avenue on the south side of Ridge Road, and John Hamacher, who ran a nursery (shown above) on the north side of Ridge Road just west of Calumet Avenue, quickly prospered. (Photo courtesy of the Munster Historical Society.)

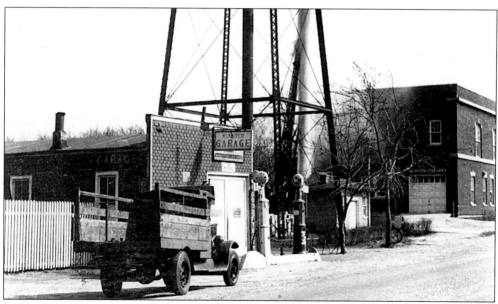

Looking to take advantage of the ever increasing automobile traffic along Ridge Road, gas and service stations soon found their way into Munster. Dick Muzzal, a local blacksmith, opened the first garage in town. He was quickly followed by numerous others, including Sam Hoekema's oil station and the Munster garage (shown above), which opened just north of the town hall on Calumet Avenue. (Photo courtesy of the Munster Historical Society.)

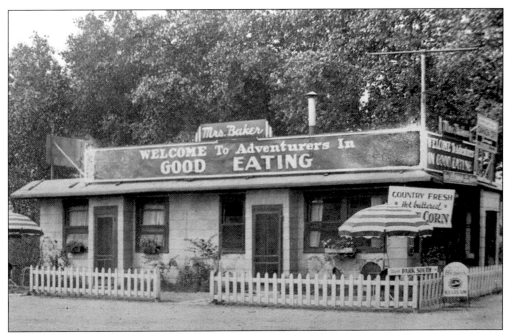

Many local travelers were greeted by the "Welcome to Adventure's in Good Eating" sign at Mrs. Ida Baker's roadside diner (shown above). Mrs. Baker's often featured home cooked meals including her famous chicken dinners and apple pie. (Photo courtesy of the Munster Historical Society.)

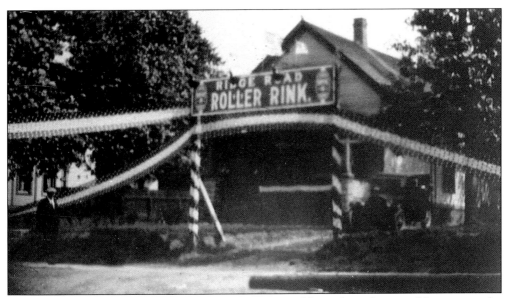

Residents seeking a little evening entertainment were able to skate their troubles away at the Ridge Road Roller Rink (shown above) owned by Mr. and Mrs. John Hesterman. Located on the south side of Ridge Road just west of Calumet Avenue, the operator's daughter, Florence Hesterman, was the 1928 Ladies World Endurance Roller Skating Champion with a record of 33 non-stop hours. In 1937, the Ridge Road Roller Rink was demolished after having been closed for a few years. (Photo courtesy of the Munster Historical Society.)

Opened in 1925, Mace's Barbecue was owned and operated by Maurice "Mace" Allen. Located on the southeast corner of Ridge Road and Calumet Avenue, Mace's patrons were greeted by an interior

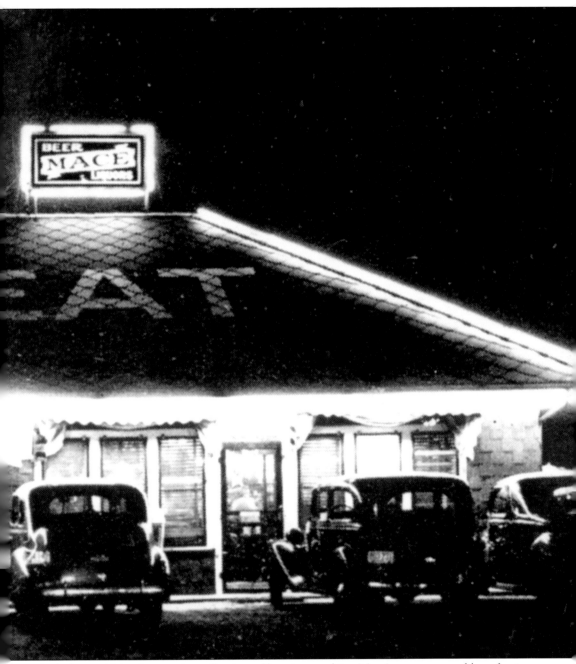
which featured Mace's extensive collection of hunting trophies. Mace's was consumed by a fire in July of 1945 and was rebuilt as The Corner. (Photo courtesy of the Munster Historical Society.)

On the evening of November 5, 1925, Hammond voted to annex the Town of Munster. Munster's town leaders wasted no time in filing a remonstration against the town's annexation and vowed to fight to the end to remain a small town. Hammond's mayor, David Brown, offered the residents improved police and fire protection and an end to Munster's water and sewage problems for only an extra $1.36 in taxes (per hundred dollar valuation). After years of legal challenges, Munster residents won the right to keep their outhouses and lower taxes. (Photo courtesy of the Munster Historical Society.)

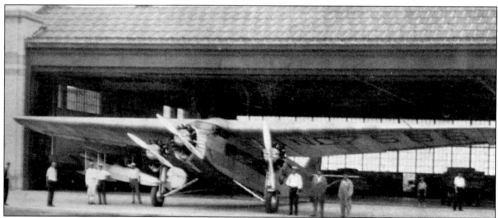

In 1926, Henry Ford, having become rich after successfully mass producing automobiles, decided that he could capitalize on America's interest in flying by mass producing airplanes. Having already established an automobile manufacturing plant in Hegwisch, Illinois, he chose a site for his "Ford Aeroplane City" that included the portion of southern Munster that is now west of Calumet Avenue and south of 45th Avenue. Coupled with 400 acres in Lansing, Ford intended to build an airplane manufacturing facility, an international airport, and a worldwide parts distribution center. By 1927, work had begun, and the airport (shown above), containing a few hangars and warehouses, was actively handling airplane traffic. Henry Ford's dreams ended with the Depression, and although the airport survived, most of the land was sold for farming. (Photo courtesy of the Munster Historical Society.)

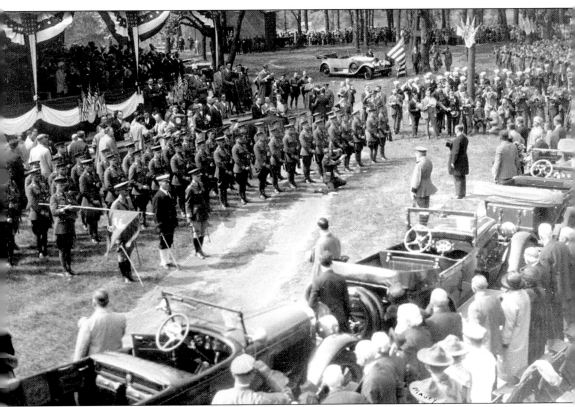

In the spring of 1927, Maurice Kraay and seven other boys formed Munster Boy Scout Troop 33 with Henry Sailor Daugherty as their Scoutmaster. Shortly thereafter, they participated in the ceremony (shown above) marking the dedication of Wicker Park by President Calvin Coolidge. (Photo courtesy of the Munster Historical Society.)

Development continued in 1927 with the opening of the Mt. Mercy Sanitarium along Ridge Road (shown from Wilson Street looking north in the photo above). Run by the Sisters of Mercy to help those suffering nervous problems, a modest two-story brick building containing 30 beds was constructed on the five acre site. In 1940, the sisters received a significant amount of local opposition when they attempted to expand their facilities. So in 1942, they relocated to Dyer and established a new facility which later became Our Lady of Mercy Hospital. (Photo courtesy of the Munster Historical Society.)

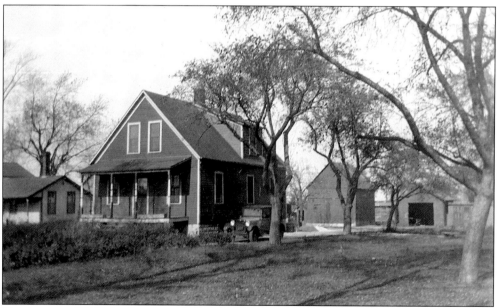

This home at 529 Ridge Road was owned by Dr. William Weis, a prominent physician and the long time health commissioner for Lake County. In addition, Dr. Weis worked closely with his nephew, Father Weis, in the development and construction of the St. Thomas More Church facilities. (Photo courtesy of the Munster Historical Society.)

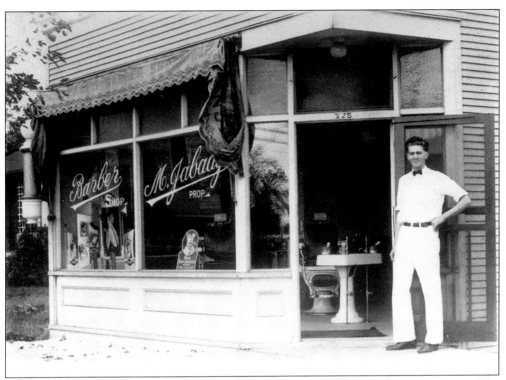

Built in 1928 at a cost of $716, the town's first barbershop (shown above) was opened by Martin Jabaay on the edge of his family's farm near the corner of Ridge Road and Hohman Avenue. Haircuts were only 50¢ and his annual property tax bill was $13. (Photo courtesy of the Munster Historical Society.)

This photo shows the rear of Martin Jabaay's Barbershop. (Photo courtesy of the Munster Historical Society.)

Despite the dramatically lower agricultural product prices of the 1930s, some family farms, such as the Schoons (shown above), continued to prosper. Most of the local food processing plants, including Meeter's in Lansing and Libby's in Highland, had closed by the mid-1930s and only the more progressive farmers that modernized and became large producers stayed profitable. (Photo courtesy of the Munster Historical Society.)

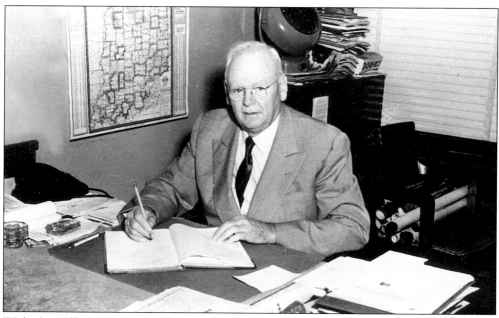

With the collapse of the Farmers and Merchants Bank of Highland in 1932, the Town of Munster faced the loss of $55,000 and the possible collapse of the town's fiscal structure. Peter Tanis (shown above), Munster's Treasurer from 1926 until 1951, successfully undertook an aggressive plan to secure additional sources of funding while working to recover the lost funds. Throughout the Depression, he and other local leaders managed to meet the town's financial obligations. (Photo courtesy of the Munster Historical Society.)

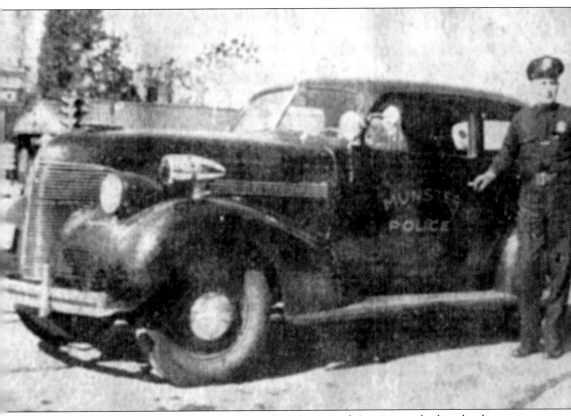

In 1934, a fire in the garage of a home located on Crestwood Avenue resulted in the discovery of an illegal still used to distill alcohol into liquor. The bootleggers and their automobiles were quickly removed from the "fashionable" area by Ed Bennett, the town's beloved and respected Marshall. (Photo courtesy of the Munster Historical Society.).

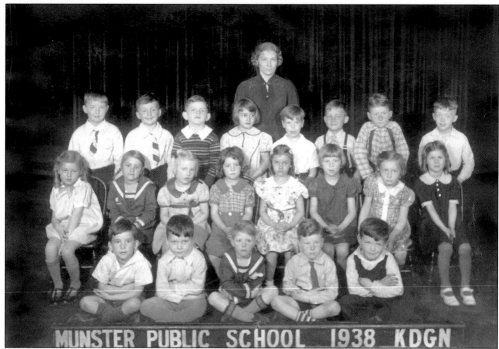

Taught as a WPA demonstration project, kindergarten was introduced to the Munster Public School in 1935. Sent from Indianapolis, Miss Cline was the school's first kindergarten teacher. The picture above shows the 1938 kindergarten class. (Photo courtesy of the Munster Historical Society.)

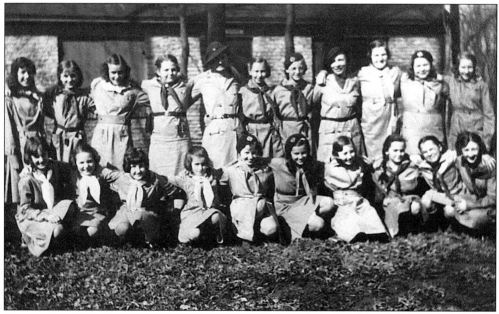

Organized in 1935, the picture above shows one of two Girl Scout troops established within the Town of Munster. The troop, the first fully uniformed one in the Hammond District, was lead by Mrs. Ray Ferguson and Mrs. C.A. Anderson. (Photo courtesy of the Munster Historical Society.)

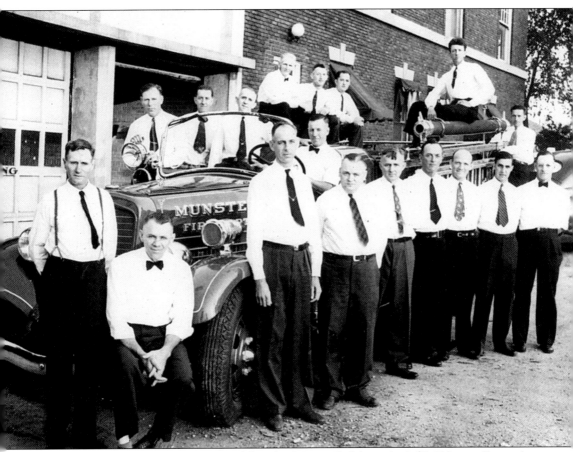

In 1937, the same year Munster's second fire chief, Peter C. Jabaay died, $3,000 was allocated for the construction of a three bay garage attachment designed to replace the one bay garage that was integrated into the rear of the town hall. The new garage, built by WPA workers, was quickly used to house the town's newly purchased 500 gallon Ahrens-Fox pumper truck. (Photo courtesy of the Munster Historical Society.)

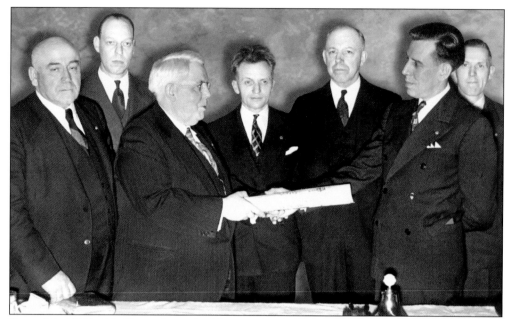

Formed in 1938 with 41 members, the Munster Lion's Club (seen here receiving their charter) quickly became the town's most ambitious service organization. Widely respected, the members passionately focused many of their early efforts on the development of the town's common areas as parks or playgrounds. The result was the creation of Community Park, which they eventually gave as a gift to the Town of Munster. (Photo courtesy of the Munster Historical Society.)

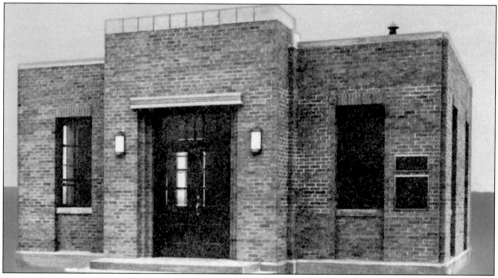

With the town's population growing and the amount of available drinking water limited, the town attempted to drill additional wells to locate an adequate supply of quality drinking water. After 20 failed attempts, it became apparent that a solution needed to be found and negotiations with the City of Hammond began in 1936. By 1940, three million gallons of Lake Michigan water a month were flowing through Hammond to Munster's new pumping station (shown above), located along Calumet Avenue, and on to 375 recently installed residential water meters. (Photo courtesy of the Munster Historical Society.)

Started in 1939, Independence Park was designed to provide affordable homes in the $2,900 to $3,800 price range. Advertised to be purchased for only $100 down and with monthly payments of $25, buyers flocked to see the White Oak Avenue model. By the end of 1940, 170 colonial-style homes, like the one purchased by the Cashman family shown above, had been built. With home construction priorities going to war workers, Independence Park continued to grow throughout World War II. (Photo courtesy of the Munster Historical Society.)

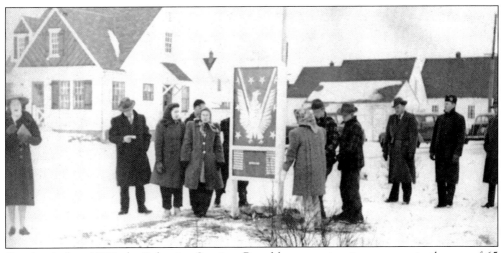

Starting in late 1940, the Selective Services Board began registering men up to the age of 65 for the draft. Throughout the war years, hundreds of men where drafted throughout Munster, while many more enlisted. Pictured above is the Annual Serviceman's Honor Roll Ceremony in Independence Park. (Photo courtesy of the Munster Historical Society.)

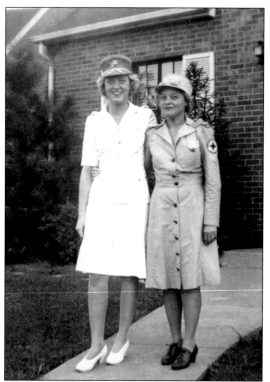

Locally, over 250 women residents of the Town of Munster joined the war effort by working tirelessly to support the American Red Cross. Others, such as Elaine Ramage, who became a Platoon Sergeant in the USMC (pictured here with her mother, Mrs. Ray Ramage, a Red Cross ambulance driver), chose to enlist and serve their country as active soldiers. (Photo courtesy of the Munster Historical Society.)

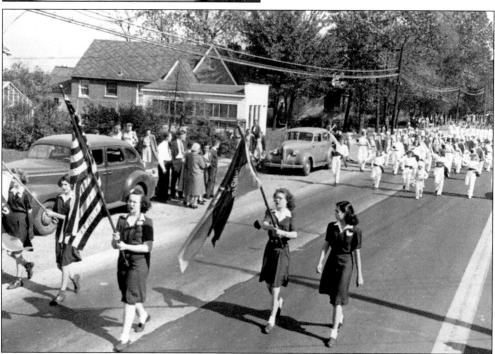

Led by a troop of Munster Girl Scouts and followed by the Munster School Band, Bond Parades along Ridge Road, like the one pictured above, were common occurrences during World War II. (Photo courtesy of the Munster Historical Society.)

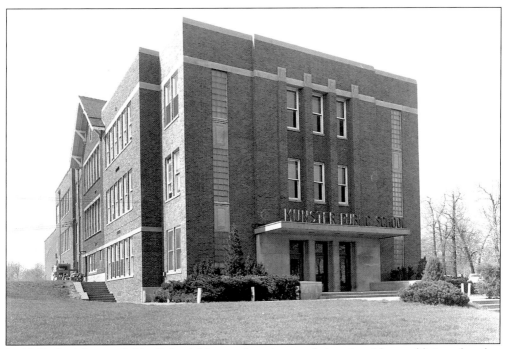

In 1942, the Munster Public School (shown above) expanded again with an addition placed at the front of the building. Four classrooms and a new auditorium were included, as well as several smaller multi-purpose rooms. (Photo courtesy of the Munster Historical Society.)

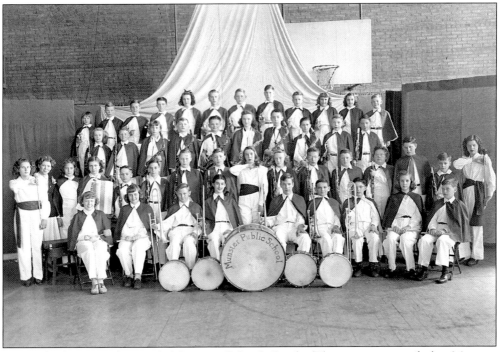

Pictured above is the 1942 Munster School Band. (Photo courtesy of the Munster Historical Society.)

At the encouragement of the Defense Housing Authority, a number of single family lots throughout the town were rezoned to support the construction of duplexes. Purchased by "War Workers," the town wisely mandated that they be constructed of brick and cost no less than $9,500. Located mostly west of the Monon tracks and north of Ridge Road, these homes, such as the one pictured above, were well built and attractively detailed. (Photo courtesy of the Munster Historical Society.)

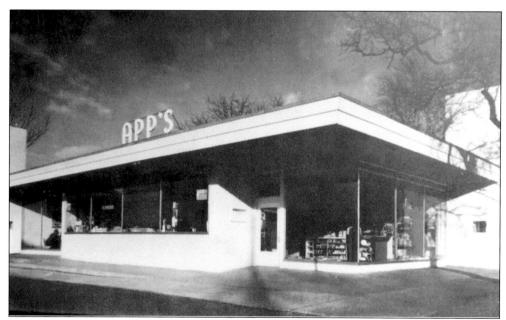

As the war came to a close, America rejoiced and optimistically began to look to the future. One business owner, J.M. App of Hammond, decided that the time was right and opened App's drug store (shown above), on the corner of Ridge Road and Hohman Avenue. (Photo courtesy of the Munster Historical Society.)

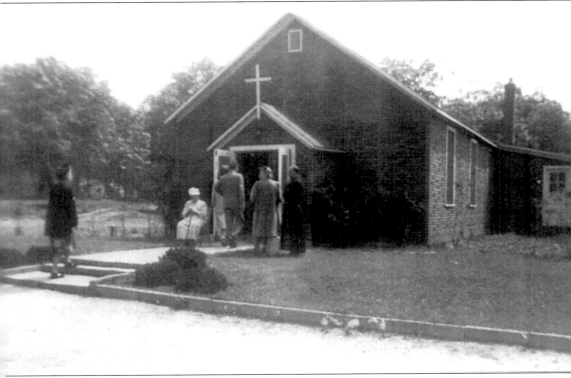

In 1945, construction began on the first St. Thomas More church (shown above) located along Calumet Avenue. Built by the parishioners, it was a simple frame building covered with asbestos shingles. Completed on February 25, 1946, Father Weis was the first priest chosen to serve the newly formed Catholic congregation. (Photo courtesy of the Munster Historical Society.)

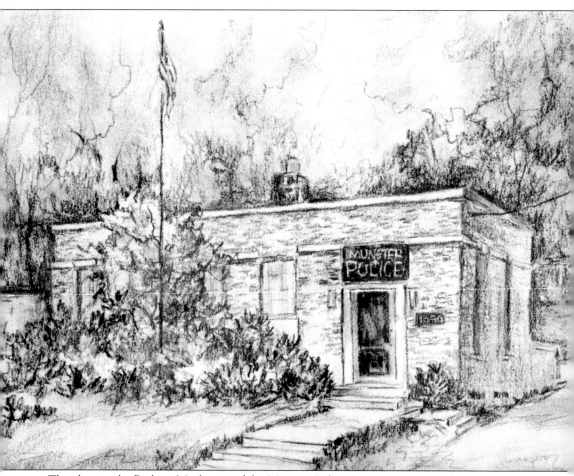

This drawing by Barbara Meekers is of the Munster Police Station. It occupied the old Munster Public Library building originally built in 1953 between Columbia and Calumet Avenues on the south side of Ridge Road. The building was used as police headquarters from 1968 until 1982. (Photo courtesy of the Munster Historical Society.)

# Four

# THE BOOM YEARS

## 1946–1969

With the war over and rationed goods now becoming available for the first time in years, the residents of Lake County, Indiana began to develop a sense of hope. Returning G.I.s quickly married and began families. The American dream of home ownership was foremost in most individual's minds and the Town of Munster became a community booming with new construction. Housing sales accelerated, and by 1955, 2,243 families resided within the town's borders. Interestingly enough, only 142 of those had roots in Munster going back more than one generation.

A survey conducted in 1955 indicated that 33 percent of the working population held managerial or professional positions, while 14 percent commuted to the City of Chicago on a daily basis. In addition, only two dentists and one doctor maintained offices within the town. For most, the employer of choice was one of the big petroleum or steel companies located along Lake Michigan. Sadly, only one percent of the town's occupants now considered themselves farmers. State studies, starting in the early 1950s, continuously showed that Munster held the honor of being the town within Indiana that had the highest median income per family. Munster had clearly become a prosperous and desirable place to live. Seemingly unstoppable, the average cost of a new home rose to $30,000 in 1969, while the town's population exceeded 15,000 residents.

With prosperity came the educational woes of growth. Subdivisions full of children rose seemingly overnight and by 1955 over one thousand students attended kindergarten through eighth grade in the Munster School System. With the defined goal of providing the absolute best education that any student could get in the State of Indiana, the school's administrators struggled with how to exceed standards and build schools simultaneously. By 1969, the Town of Munster had successfully built five schools that housed over 4,000 students and was producing graduates destined to have exceptionally promising futures.

Likewise, entrepreneurs, spurred on by the population growth, began to build businesses to cater to the needs of the local residents. Construction companies, realtors, grocers, druggists, butchers, service stations, banks—over one-hundred retailers in all—built or expanded between 1945 and 1969. With them came the development of many commercial areas around town, most with parking in front of their stores. Also looking for well managed communities, many successful light manufacturing and distribution businesses began to relocate to Munster. By 1969, the transition from a farm town to a quiet residential community had been completed with most farming families having moved to the spacious lands of southern Lake County.

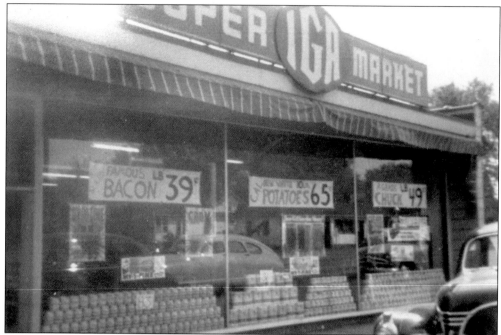

One of those quick to recognize the growth potential of Munster was Joseph Burger, a grocer with another store in Glen Park. In 1946, he opened an IGA grocery store (pictured above) on Hohman Avenue just north of Ridge Road. Catering to new and old residents alike, his grocery store offered services previously not available in the community and quickly became a success. (Photo courtesy of the Munster Historical Society.)

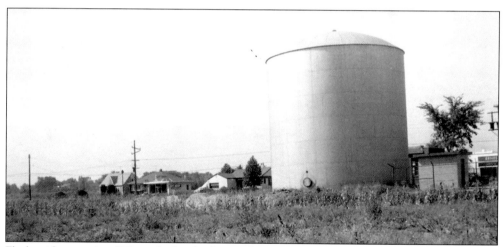

Flush with returning G.I.s and a bright future, the City of Hammond once again began making overtures towards the annexation of the Town of Munster. Throughout the late 1940s and early 1950s, verbal battles waged between the two communities. However, as in the past, the issue was resolved with water. First a pair of half-million gallon storage tanks, one of which is shown above, were built on the corner of Calumet Avenue and Broadmoor to relieve supply problems. Then, faced with the cost of building a sewage treatment plant, the town wisely agreed to join Hammond's Sanitary District, bringing to an end the argument that Munster could not offer its citizens "proper" services. (Photo courtesy of the Munster Historical Society.)

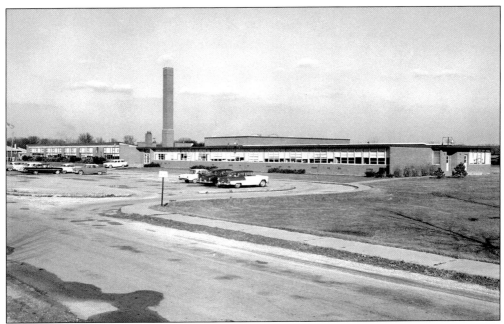

One of the immediate needs of the community became obvious in 1947. With an enrollment of 610 students in the Munster Public School and 80 more children posed to enter the school system within the next year, it became apparent that a new school needed to be built. A site was selected east of the Monon tracks and north of Broadmoor Avenue. Ten acres of land was purchased at a cost of $750 an acre and construction began in early 1948. The James Buchanan Eads School, shown above, named for a pioneering civil engineer, offered classes for kindergarten through sixth grade children that lived in homes west of Calumet Avenue. (Photo courtesy of the Munster Historical Society.)

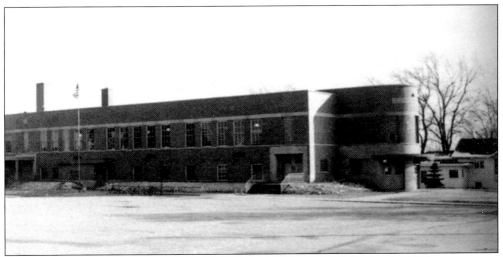

Spurred by the early growth of his congregation, Rev. Robert Weis oversaw the 1948 construction of a second Saint Thomas More facility. It housed a school for children in grades one through six, a convent for the Sisters of St. Benedict, the school's teachers, and a modest, but larger chapel. When opened in 1949, the school, shown above, was attended by 98 children. (Photo courtesy of the Munster Historical Society.)

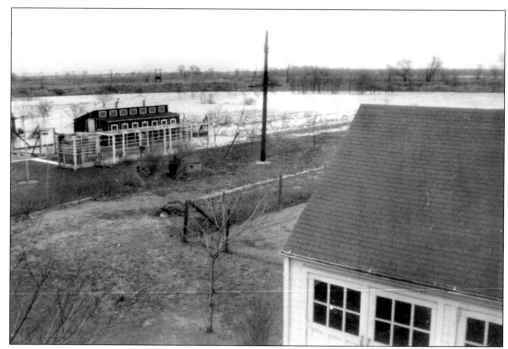

Despite the uncertainty of flooding, as shown by this 1947 northward view from a window in a home located at 8041 Greenwood Avenue, homes were rapidly filling the northeast corner of town. Although only 36 homes were constructed in 1946, 1947 and 1948 saw the construction of almost 60 homes with many more in the planning stages by 1949. (Photo courtesy of the Munster Historical Society.)

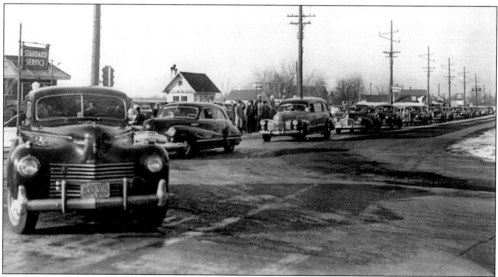

In 1947, tragedy struck the Town of Munster when the Town's Marshall, Charles Chapman, was shot to death while on duty at his desk inside the town hall. Ruled an accident, Marshall Chapman was killed by a stray bullet inadvertently discharged from a fellow officer's gun. As seen in the photo above, the community gathered to view the funeral procession and honor the fallen officer. (Photo courtesy of the Munster Historical Society.)

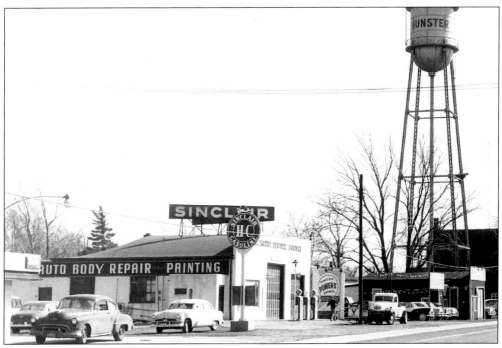

Myron Smith's garage, pictured above, was the Saturday morning meeting place for members of Munster's late 1940s Conservation Club. Known for their frequent fox hunts, the club also undertook efforts to stock the local lakes with game fish and the woods with pheasants. The late 1940s and early 1950s gave birth to many of the town's social and civic clubs. (Photo courtesy of the Munster Historical Society.)

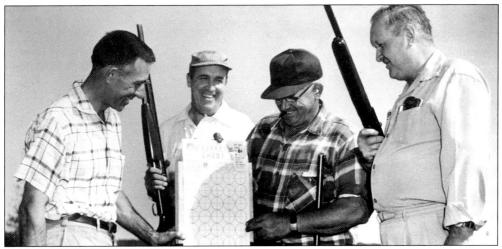

In 1948, the idea of a "Community Park" was conceived by the Lion's Club based on their early pre-World War II efforts to organize a community parks and recreation program. By 1951, the Lion's Club had acquired 20 acres of land along Calumet Avenue and had helped to establish the Munster Community Park Association. Local residents and businesses quickly joined the new organization. Annual membership dues were used to purchase more land, and fund raisers, such as the Annual Turkey Shoot pictured above, contributed to funds used to develop the park. (Photo courtesy of the Munster Historical Society.)

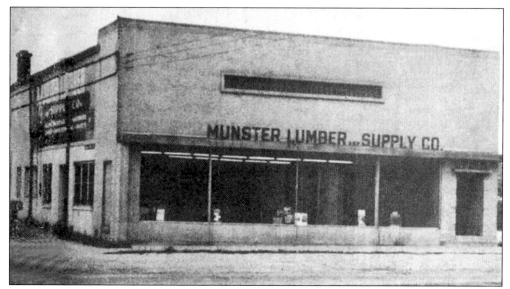

One of the main beneficiaries of the town's construction boom was the Munster Lumber and Supply Company. Located just west of the Monon tracks and south of Ridge Road, on what once was the unofficial town dump, it was opened in the early 1920s as the McFarland Lumber and Coal Yard. Sold to Fred Papke in 1928, it was renamed the Munster Lumber and Supply Company and truly began to prosper in the late 1940s and early 1950s. (Photo courtesy of the Munster Historical Society.)

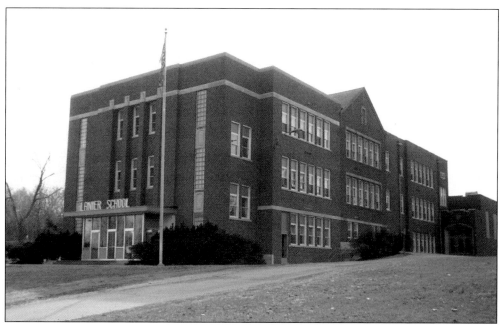

The Munster Public School, now one of two public schools in town, was renamed in 1950 to reflect the industrialist themes of the day. Called the James Franklin Doughty Lanier School, or Lanier School (as pictured above), it was named in honor of the patriot and financier who twice saved the State of Indiana from bankruptcy during the Civil War. (Photo courtesy of the Munster Historical Society.)

Conceived in 1950 and dedicated in 1952, the Ernest R. Elliot School (pictured above) was built on the corner of 36th Street and White Oak Avenue. Named after the town's first school superintendent, who retired the same year, the building was constructed at a cost of $300,000. It was designed to offer classes to kindergarten through sixth grade children that lived in homes east of Calumet Avenue. Shortly thereafter, Lanier School became a junior high school serving only 7th and 8th grade students. The original building was demolished in 2003. (Photo courtesy of the Munster Historical Society.)

One of Munster's few murder mysteries occurred in 1950. On the evening of April 7th, George Pappas and his young wife, Josephine, were found dead in their home on the corner of Forest Avenue and Adelaide Place. After an intensive investigation by Town Marshall Adam Funk (pictured here), Josephine's brother, Victor Smelko was charged with the double murder. Purported to be insane, Victor recanted an earlier crazed confession resulting in two trials with hung juries. After a third trial in 1952, Victor was found innocent and once released from jail quickly disappeared. To this day the murder remains unsolved, although the house received the maximum penalty; it was demolished. (Photo courtesy of the Munster Historical Society.)

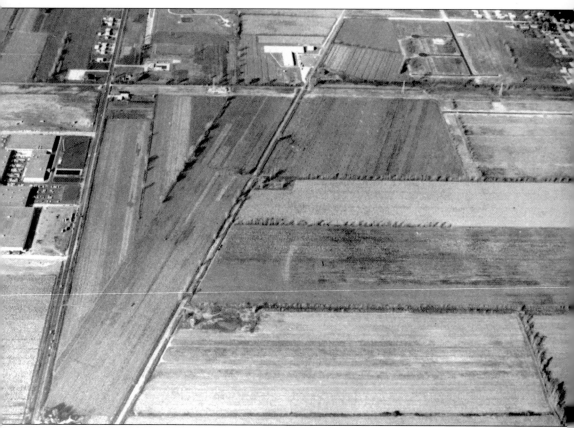

In 1951, the Purdue University Research Foundation began to purchase land in Munster for the development of a proposed Purdue University Regional Campus. By 1952, 783 continuous acres of land had been acquired just north of 45th Avenue and east of Calumet Avenue. After the decision not to build the campus in Munster was made, Purdue commissioned the creation of a subdivision plan for the site which it called Munster Plains. Rather than develop the property themselves, it was contracted for development in 1961. (Photo courtesy of the Munster Historical Society.)

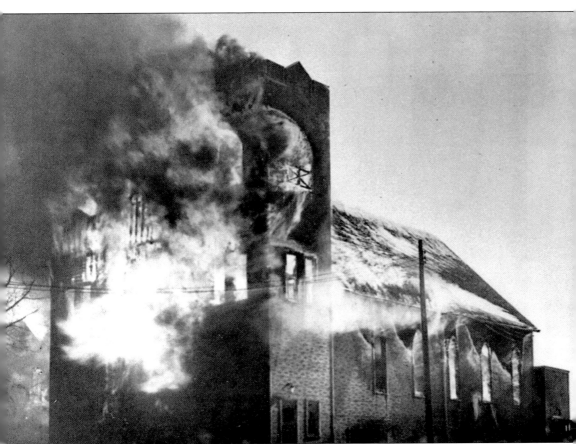

Having been remodeled and moved back from the road in 1940, the Christian Reform Church caught fire in January of 1952. In one of Munster's most spectacular fires, and despite the efforts of the town's heroic volunteer fire department, the building burned to the ground in only a few hours. In resounding faith, the parishioners quickly rebuilt the church with even more majesty. (Photo courtesy of the Munster Historical Society.)

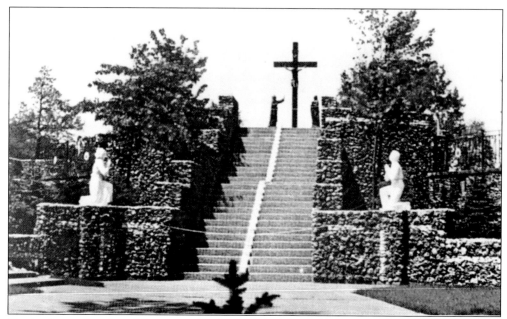

Having been abandoned for years, the former Mt. Mercy Sanitarium was purchased in 1952 by Father Bernard Ciesielski for an Order of Carmelite Monks. A monastery was established, and monks displaced by World War II and the subsequent communist occupation of Eastern European countries began to arrive at this, their new home. Shortly thereafter, the friars began to build a series of shrines representing each Station of the Cross. Hand built of exquisite and rare materials, the public grottoes quickly became a designation for those seeking to enrich their lives through prayer. (Photo courtesy of the Munster Historical Society.)

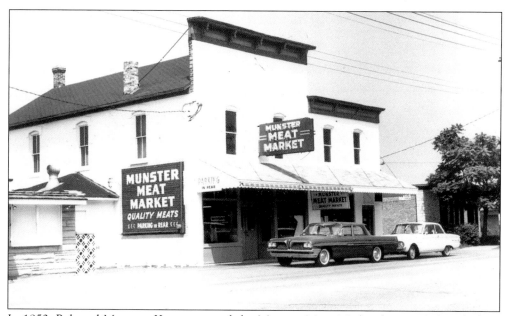

In 1952, Bob and Margaret Kroner opened the Munster Meat Market (pictured above) along Ridge Road. Once the Klootwyk General Store, they offered freshly butchered meat and mainstay grocery items for sale. (Photo courtesy of the Munster Historical Society.)

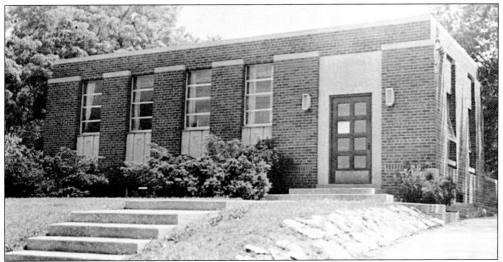

Until 1953, Munster's Public Library consisted of a small 20-foot by 20-foot wooden frame building that had once been a sales office for the Wicker Park Estates subdivision and was relocated across from the Munster Public School to the corner of Ridge Road and Howard Street. Heated by a wood burning stove and without plumbing, the town's residents began a campaign to replace it in 1949. With land adjacent to the school donated by Wilhelmina Kaske, construction began on a modest single story brick building with a basement (shown above), which was completed in August of 1953. (Photo courtesy of the Munster Historical Society.)

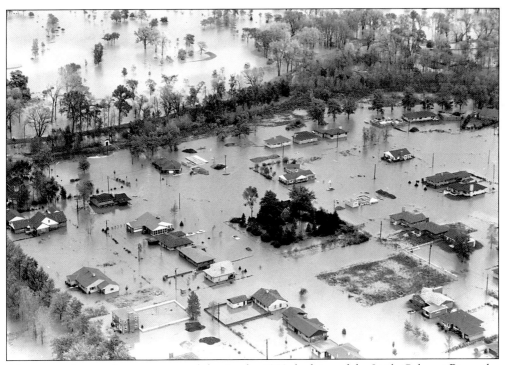

After years of expressing concerns and despite the 1942 dredging of the Little Calumet River, the homeowners living south of the river and west of the Hart Ditch found themselves immersed in flood waters after a massive rain storm in 1954. (Photo courtesy of the Munster Historical Society.)

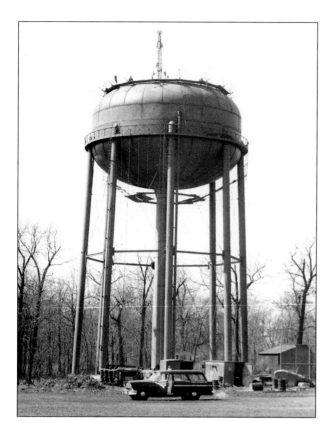

The water department, realizing the need for additional water storage capacity, issued a bond for $344,000 to build a half-million-gallon tank behind Lanier School. The tank (pictured here) was completed in 1955. Additional tanks were built around town in the late 1960s and early 1970s to satisfy resident's ongoing demands for water. (Photo courtesy of the Munster Historical Society.)

By the mid-1950s, the land along Columbia Avenue (shown above) and south of Ridge Road was being developed. Subdivisions by the name of White Oak Manor, Hill and Vale, Walnut Hills, Knickerbocker Manor, and many others were underway. Hundreds of homes were being built south of Ridge Road for eager home buyers. (Photo courtesy of the Munster Historical Society.)

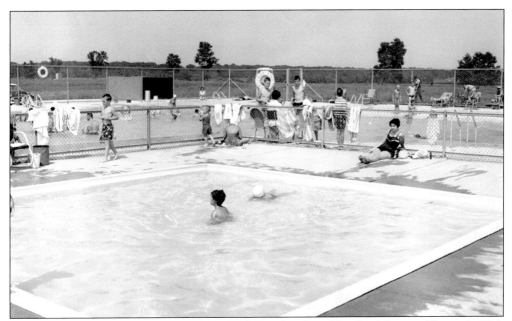

The concept of a Munster Community Pool was developed by the Munster Woman's Club in May of 1955. With support from the local community and a bond drive to raise funds, "Operation Cool Plunge" had collected over $75,000 by early 1956. A site was quickly found on the corner of Calumet and Fisher Avenues, just south of Community Park. After considering multiple designs, a beautiful 42-foot by 82-foot "L" shaped pool was built, and by July of 1956, the town's residents were splashing freely in the cool waters of the new pool. (Photo courtesy of the Munster Historical Society.)

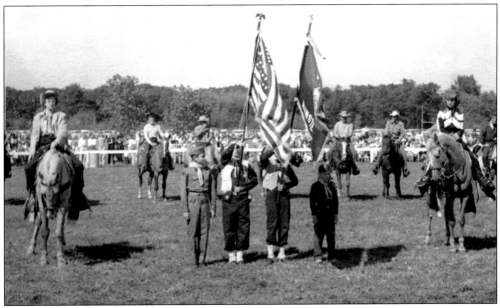

Starting in 1955, the Lion's Club sponsored an annual Horse Show at Community Park. In this photo, the Munster Boy Scouts from Troop 33 are preparing to start the 1956 horse show. (Photo courtesy of the Munster Historical Society.)

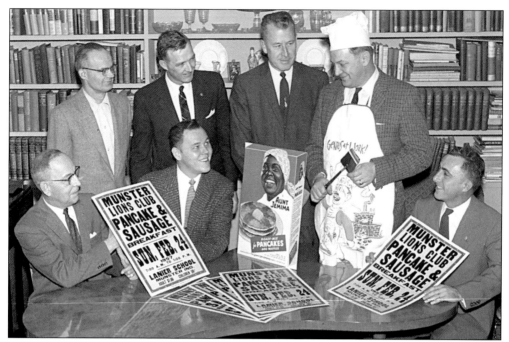

The Lion's Club had their inaugural pancake breakfast in 1957. Shown above are its organizers. An annual event, it is a favorite among the town's residents and to this day it often draws distant family members and friends alike. (Photo courtesy of the Munster Historical Society.)

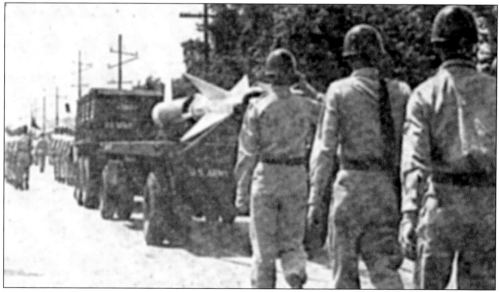

With the cold war at its height, this 1957 parade included a regiment of soldiers and a Nike missile. Located along Sheffield Avenue in southwest Munster, the Nike Missile Base, opened in 1956, contained multiple underground missile launchers and an operations team of approximately 100 servicemen. By 1960, the original Nike missiles and their Ajax missile replacements had been upgraded to the newer long range atomic capable Hercules missiles. Active until 1968, the base was a constant reminder of the threat facing America. (Photo courtesy of the Munster Historical Society.)

Although mostly a quiet town, other activities were also on the rise within the Town's borders. After Mace's Bar-B-Q burned down in late 1945, "The Corner" restaurant was built in its place. Despite its prominent location, across the street from the Munster Town Hall (as seen in the picture above), it was frequently raided by law enforcement officials in the 1960s for its supposed gambling and bookmaking activities. (Photo courtesy of the Munster Historical Society.)

A community landmark for years, the Indiana Café, located on the northwest corner of Calumet Avenue and Ridge Road was a favorite eatery for many local residents until its demise in the late 1960s. (Photo courtesy of the Munster Historical Society.)

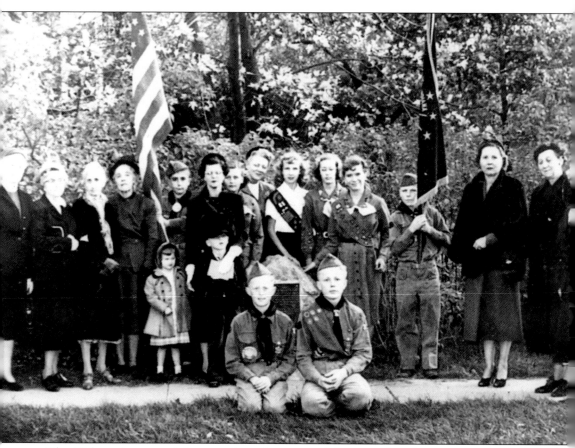

The 50th anniversary of the town brought many celebrations, but the most significant was the rededication of the 1926 memorial identifying the historical importance of the property located on the southeast corner of Columbia Avenue and Ridge Road. (Photo courtesy of the Munster Historical Society.)

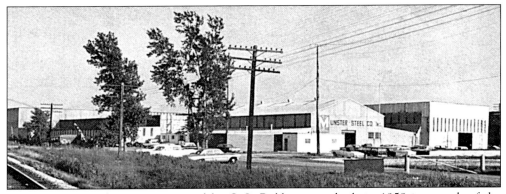

The Munster Steel Company, owned by O.C. Robbins, was built in 1958 just north of the Brickyard along Calumet Avenue and the Grand Trunk Railroad tracks. Pictured above, it occupied a fabricated steel building and employed approximately 100 workers engaged in the manufacture of steel structural components used in the commercial construction of buildings and bridges. (Photo courtesy of the Munster Historical Society.)

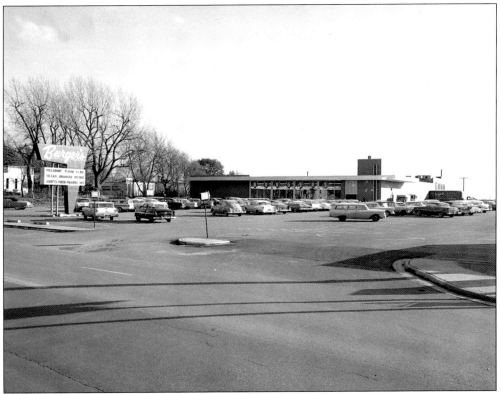

In September of 1959, Joseph Burger relocated his Hohman Avenue store to a new larger store (shown above) located just east of the Illinois State line at 12 Ridge Road and just west of Hohman Avenue. However, the store's construction was not to be without some intrigue. During the grading of the parking lot, a potter's cemetery was unearthed when bones and other artifacts were discovered in a delivery of sand removed from the location. Not wishing to disturb the site's spirits any more than necessary, the parking lot was promptly paved. (Photo courtesy of the Munster Historical Society.)

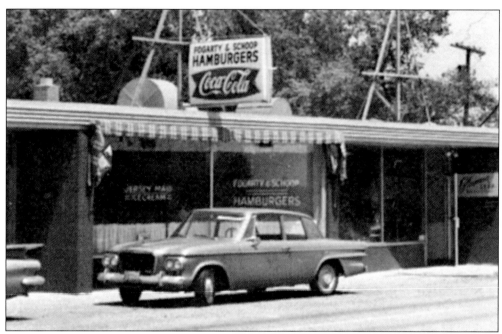

Now a town treasure, Fogarty and Schoop Hamburgers was opened in 1959 at 215 Ridge Road. Serving fresh hamburgers, fries, delicious milk shakes, and featuring jukebox music it soon became one of the town's most popular places. In 1964, Allen Schoop bought out his partner, Art Fogarty, and the restaurant simply became known as Schoop's. (Photo courtesy of the Munster Historical Society.)

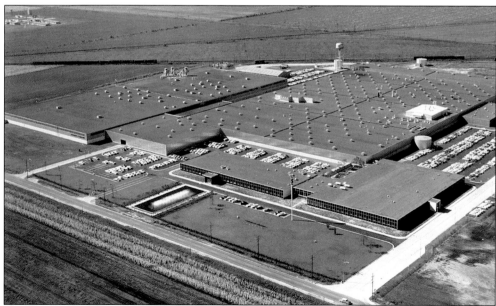

Completed in 1960, the Simmons Company (shown above) opened a three building plant site with one million square feet of production and distribution space. Located on Calumet Avenue, the plant employed over 1,600 people and was a model production facility until it closed under restructuring in 1978. (Photo courtesy of the Munster Historical Society.)

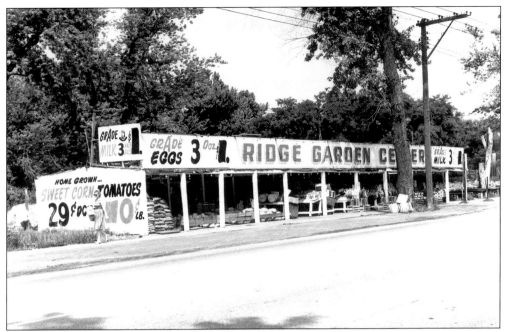

Some things in town remained constant even through the boom years. The Ridge Garden Center opened in 1934 as a farm stand and continued to sell local produce at an attractive price despite the growth occurring around them. Shown in this 1960 picture, the stand, which eventually developed into a nursery, remained a fixture in town until the late 1990s when it was replaced by an office complex. (Photo courtesy of the Munster Historical Society.)

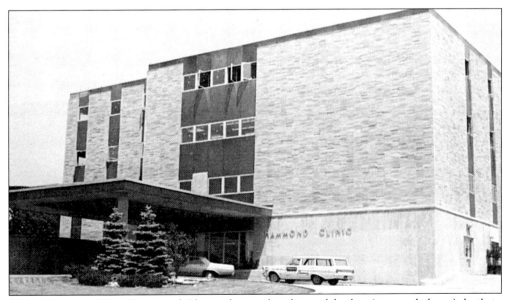

Although named The Hammond Clinic, the newly relocated facility (pictured above), built in 1961, opened just south of the Little Calumet River along the east side of Calumet Avenue in Munster. With 15 physicians and specialists, the clinic quickly developed into a facility with 60 physicians. In 1971, it partnered with the newly established Munster Med-Inn to offer services to long-term care patients. (Photo courtesy of the Munster Historical Society.)

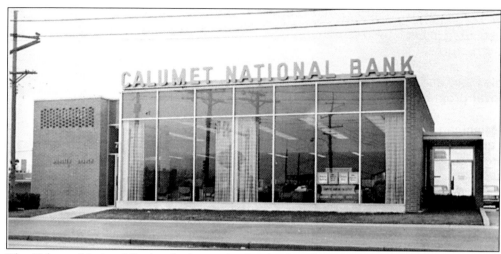

The Calumet National Bank, which was the first bank to locate in Munster, built this unique glass structure (shown above) on the southwest corner of Ridge Road and Calumet Avenue in 1962. Soon thereafter, numerous other banks joined the community by building similar offices around town. (Photo courtesy of the Munster Historical Society.)

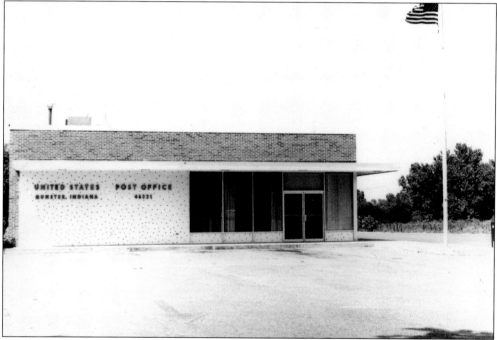

Starting with Jacob Munster's contracted U.S. Postal Station, the Town of Munster's mail had always been delivered to the City of Hammond's Post Office and routed to the town, either through a contracted station or by a rural route delivery. In 1951, the town, desperate to secure modern postal services, petitioned the U.S. Postmaster General for the creation of a Munster Post Office. Approved in 1953, the postal authorities selected a 1,800 square foot building located at 436 Ridge Road to serve as the town's first postal facility. However, in 1964 the post office moved out of their leased facilities into a new 5,000 square foot facility (pictured above) located in a commercial area just off Ridge Road. (Photo courtesy of the Munster Historical Society.)

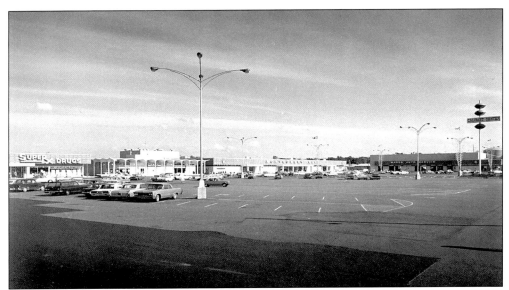

The Calumet Center (shown above), a "high class" shopping center, was opened in August of 1964 along Calumet Avenue and north of Broadmoor Street. Developed by Edward J. DeBartolo, it included a Montgomery Ward's general merchandise store, a Kroger's grocery store, a Super X drug store, and a McCrory's dime store. Constructed on land owned by the Gescheidler family, it opened to large crowds of eager shoppers. (Photo courtesy of the Munster Historical Society.)

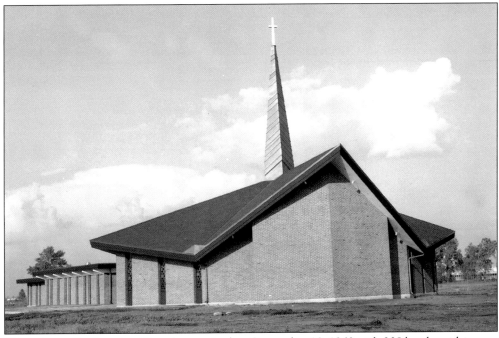

Westminster Presbyterian Church organized on September 18, 1962 with 208 local parishioners. On Palm Sunday in 1965, the first worship services were held by Reverend Gregg in the new sanctuary built on five acres of land at the corner of Elliot Drive and Columbia Avenue. That same evening, high winds knocked down the steeple which was still under construction at the time. (Photo courtesy of the Munster Historical Society.)

This photo, taken in the mid-1960s, shows Ridge Road facing east from the intersection of Calumet Avenue and Ridge. A sign was placed in the center of the street during school hours to warn drivers to reduce their speed. (Photo courtesy of the Munster Historical Society.)

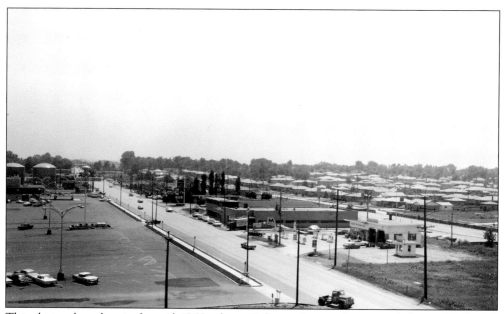

This photo, also taken in the mid-1960s, shows Calumet Avenue facing south from a window in the Hammond Clinic. Munster Lanes, a bowling alley, can be seen just across the street. (Photo courtesy of the Munster Historical Society.)

Throughout the mid-1950s, seventh and eighth grade enrollment in Lanier School grew no less than nine percent annually. Most students then continued on at one of the surrounding high schools, usually Hammond High School, Hammond Technical School, or Griffith High School. It was becoming apparent that overcrowding at Lanier School and the surrounding high schools was going to require the school system to make dramatic changes. In 1958, a site along Columbia Avenue (pictured above) was chosen for the construction of a new Junior High School. Completed in 1960, it served the communities seventh, eighth, and ninth grade students and was named Wilbur Wright Junior High School based on a naming contest won by Julane Kraay. (Photo courtesy of the Munster Historical Society.)

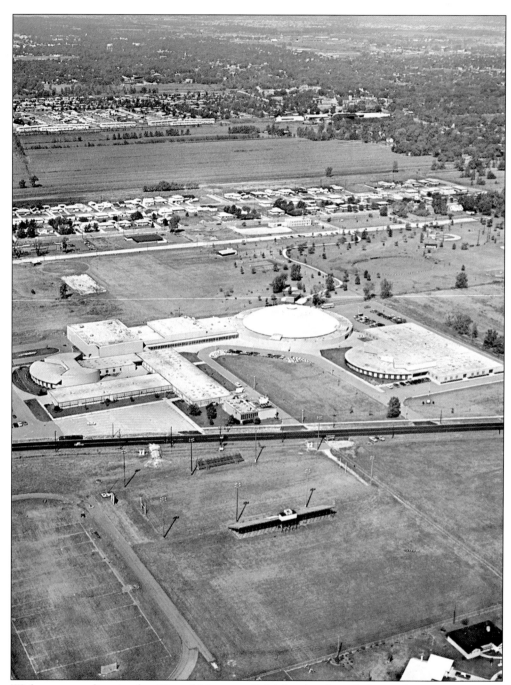
With overcrowding in the City of Hammond's high schools and their reluctance to accept additional students from the Town of Munster, the construction of a high school in Munster became a priority in 1963. With sophomores and juniors attending Wilbur Wright School in 1964 and 1965, construction began on a $4 million dollar facility that would house approximately 1,200 high school students. Attached to the junior high building, the classrooms were completed just in time for the 1966–1967 school year to begin in the new Munster High School. (Photo courtesy of the Munster Historical Society.)

A family favorite, the Munster High School Debate Team's traditional barbeque chicken dinner (shown here) was conceived in 1967 and introduced in 1969. Served just prior to the Munster High School Football Team's homecoming game, it was and still is a welcome fund raiser looked forward to by many. (Photo courtesy of the Munster Historical Society.)

The year 1968 brought the introduction of the E.J. Higgins Pepsi-Cola Bottling plant to Munster. Under construction since 1967, the 160,000 square foot plant contained the world's first computer controlled bottling assembly line. In addition, it employed over 300 workers producing and delivering Pepsi-Cola products to 13 counties in the states of Indiana and Illinois. Munster's children quickly became the area's first Pepsi generation. (Photo courtesy of the Munster Historical Society.)

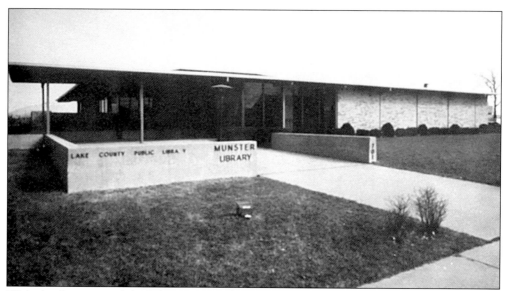

With the formation of the Lake County Library system in 1959, Munster and the surrounding communities were facing a tax increase to cover the cost of library facilities. The towns' trustees wisely negotiated an agreement with the library board for the construction of a new library facility on land adjoining Community Park along Calumet Avenue. At a cost of $200,000 and with 6,300 square feet of space, the library (shown above), with public meeting rooms and open areas, was completed in 1968. (Photo courtesy of the Munster Historical Society.)

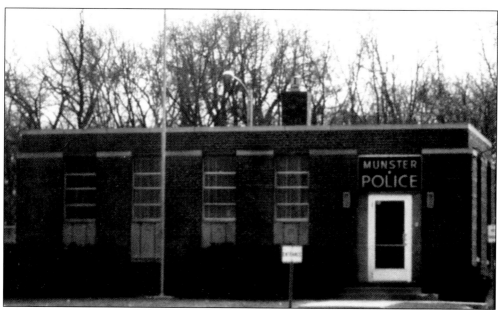

After the construction of a new library, the town's trustees decided to remodel the old library building into a home for the Munster Police. Opened in 1968, at a cost of $40,000, the new Munster Police Station (shown above) had four cells to hold unruly prisoners, a darkroom to process crime scene photographs, and a state of the art radio transmitter. With a budget of $283,000, Police Chief William Retzloff was ready to tackle the town's criminals. (Photo courtesy of the Munster Historical Society.)

By 1969, homes were rising at a rate of approximately 250 per year and the average home was selling for approximately $29,000. Homes, like the ones shown above, were being built on available lots throughout town. Except for the undeveloped land that lay south of 45th Avenue, the Town of Munster was quickly being transformed into a suburban community. (Photo courtesy of the Munster Historical Society.)

With the development of hundreds of homes on Munster's south side, the school system chose to exercise an option to purchase 24 acres of land along newly formed Fran-Lin Parkway. Designed as a 24 classroom facility, Frank H. Hammond School, named after the retiring school superintendent, was completed in 1969. Costing only $1.4 million dollars and with 588 children in attendance, the completed school was one of the most successful projects ever undertaken by the school system. (Photo courtesy of the Munster Historical Society.)

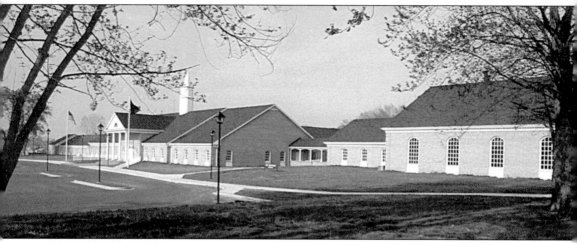

This photo shows the Munster Town Hall. It was completed in 1982 on 7.8 acres of land on the northeast corner of Tapper Avenue and Ridge Road. The building contains the Town's Police Headquarters, Fire Station Number One, the offices of the Munster Historical Society, the Town's Building Department, the offices of the Town's Parks and Recreation Department, the offices of the Town Manager, the Town Clerk's offices, as well as numerous meeting rooms used by the Town Council and others to conduct the town's business. (Photo courtesy of the Munster Historical Society.)

# Five

# Suburban Lifestyle

## 1970–1989

With a population of over 16,000 residents in 1970, the Town of Munster was quickly becoming a suburban community filled with young families interested in a lifestyle filled with educational opportunities, community sports, and social events. Residents enjoyed the use of numerous new parks, ball fields, bike routes, and planned recreational events designed to highlight them. The bicentennial celebration of 1976 presented an even stronger sense of nation and community with the town offering a dizzying array of activities. By 1977 and the addition of Community Park, which was donated by the Lion's Club, the town was secure in its active, yet suburban role.

With the student population peaking at 4,700 students in 1973 and edging downward to 3,400 students by 1980, teacher and administrative relations were often tense. However, despite a fluctuating educational environment, Munster's students continued to excel in both academic and extracurricular activities. The 1970s saw numerous regional, state, and national championships awarded to the school's academic and sports teams. In addition, the student body began a long standing tradition of academic excellence.

With northern and central Munster mostly populated, developers began to turn their attention to southern Munster. By the late 1970s, a significant number of homes had been built by local developers just north of 45th Avenue—Don Powers, George Watson, Harold Rueth, and William Brant. Despite land prices being at a premium, new home buyers began to turn their attention to the open land south of 45th Avenue. By the end of the 1980s, a number of major subdivisions were under development and many more were in the planning stages. With the development of two new roadways leading to the south and west, and the creation of an industrial park in the southwest corner of town, Munster found itself as an attractive place for both employees and employers.

The development of Community Hospital in the early 1970s helped to solidify the town's position as a suburban community. Along with the relocation of numerous medical professionals, the hospital spurred a number of ancillary businesses associated with the health care industry. Soon the town was flourishing with individuals involved in the development of medical systems, the care and support of patients, the delivery of ambulatory services, and many others. Quite a change for a town founded by Dutch farmers.

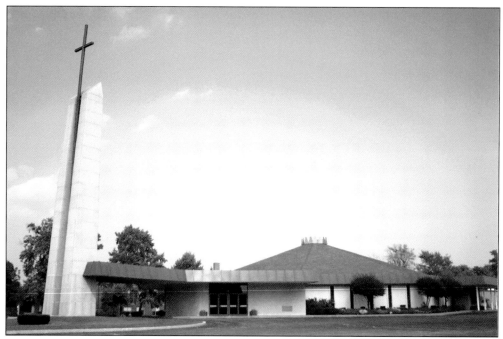

Celebrating the completion of their third facility in May of 1970, the new St. Thomas More church offered parishioners a choice of 1,200 seats and a reverent view of the altar. (Photo courtesy of the Munster Historical Society.)

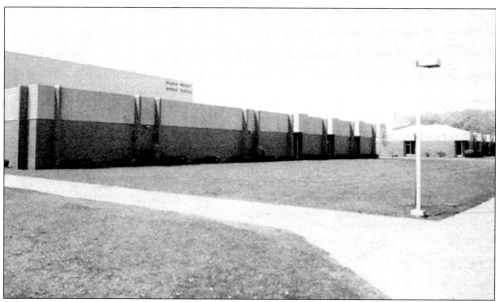

Dedicated on November 5th, 1972, Wilbur Wright Middle School was originally designed as a concept school. Many learning areas were built without ceiling to floor walls creating "open air" classrooms or lecture halls. In addition, a "team teaching" approach was utilized by educators as an alternative to traditional methods and students were encouraged to stimulate free format discussions by expressing their opinions on a variety of topics. (Photo courtesy of the Munster Historical Society.)

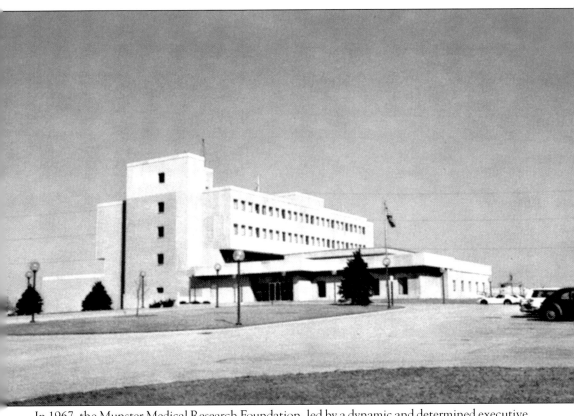

In 1967, the Munster Medical Research Foundation, led by a dynamic and determined executive director named Edward P. Robinson, announced plans to construct a 10 story non-profit hospital on an undeveloped site adjacent to the Hammond Clinic. However, concerns relating to the placement of a non-profit hospital next to a for-profit medical facility suggested another site should be selected. The second site chosen was a parcel of 14 acres of land extending along Tapper Avenue between Ridgeway and Broadmoor Avenues. With local residents opposed to the rezoning of residential land, a third site was chosen between Calumet and Columbia Avenues just south of Fisher Street. It quickly won the approval of the town council. Despite this victory, it took years of relentless fund raising to accumulate the monies needed to build the modest 104 bed Community Hospital which opened in August of 1973. (Photo courtesy of the Munster Historical Society.)

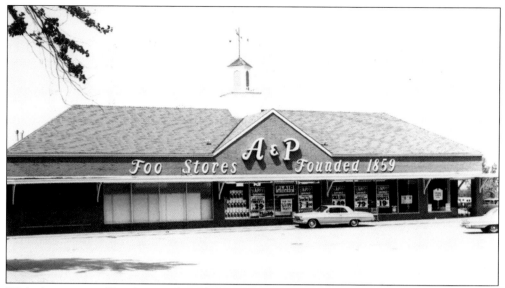

With the success of local grocer Joseph Burger's store on Ridge Road and his 1970 expansion to a second Munster location along 45th Avenue, national grocery chains such as A&P, Kroger, and Jewel quickly took notice and built stores offering a wide variety of goods. Unfortunately, most realized too late that the community was loyal to Mr. Burger's home town style of value and by 1976 many, such as this A&P located just off the northeast corner of Ridge Road and Calumet Avenue, were cutting their losses and closing their doors. (Photo courtesy of the Munster Historical Society.)

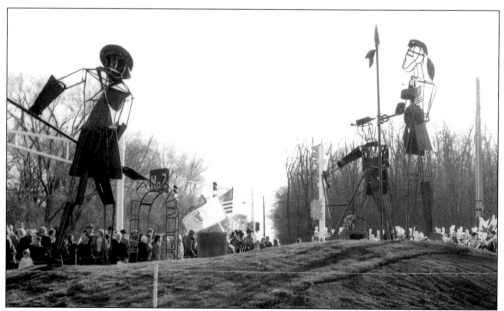

As part of the town's 1976 Bicentennial Celebration, the Munster Rotary Club, which was founded in 1969, commissioned the design of three Corten steel figures by local artist Fred Holly. Manufactured by William Ores, the figures represent an American Indian as an original inhabitant, a settler as the one who farmed the land, and a steelworker as having been the one to transform the area into a prosperous community. (Photo courtesy of the Munster Historical Society.)

By the late 1970s, mortgage rates were escalating and new home construction had slowed to less than a hundred homes a year. However, the Twin Creek subdivision, the first to be developed south of 45th Avenue, continued to see growth with the construction of large upscale homes. (Photo courtesy of the Munster Historical Society.)

By the mid to late 1970s, the town had undertaken numerous road construction projects designed to improve the flow of traffic through the community. Ridge Road had been improved, 45th Avenue had been extended into Illinois, and Azalea Drive had been extended into Highland. The southern most through-fares were now being more heavily used and as the 1980s began, so did construction on the town's southern routes. (Photo courtesy of the Munster Historical Society.)

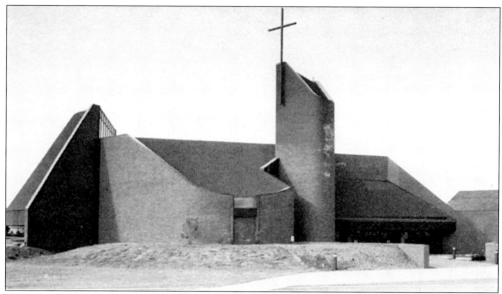

Starting with a groundbreaking ceremony in the summer of 1978, this multi-million dollar chapel and school, located on the corner of Briar Lane and Harrison Street, was completed in 1979 for the parishioners of St. Paul's Evangelical Lutheran Church. (Photo courtesy of the Munster Historical Society.)

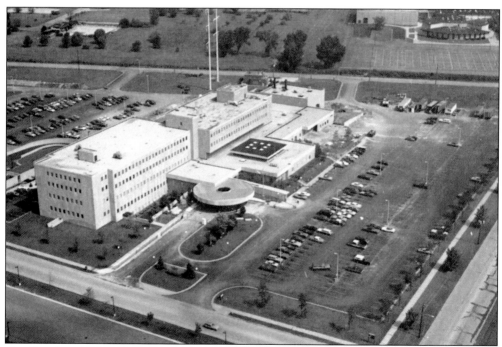

On October 15th, 1979, while the finishing touches were being put on the recently constructed Community Hospital South Pavilion, Angie Wilson was being delivered as the first baby born in the newly organized Obstetrics Unit. Coupled with Emergency Room Operations, it marked the beginning of Community Hospital's role as a full service hospital. (Photo courtesy of the Munster Historical Society.)

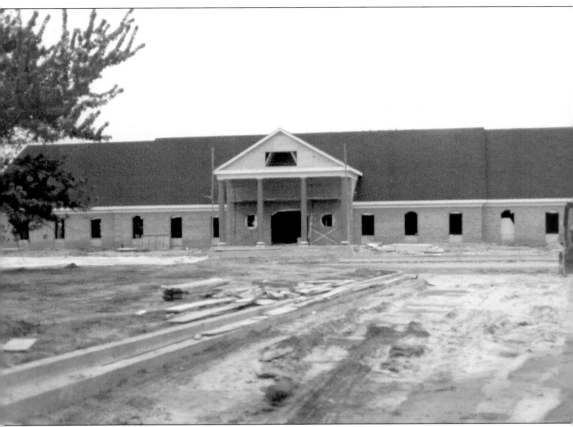

With construction beginning in September of 1980, the Munster Town Municipal Complex was underway. Designed as three distinct colonial brick structures connected by covered walkways, the 12,000 square foot north wing houses the police department. The 6,000 square foot south wing houses the fire department, and the 20,000 square foot central wing houses the town's administrative offices. Dedicated on July 4th of 1982, it marked the end of 61 years of use for the old town hall. (Photo courtesy of the Munster Historical Society.)

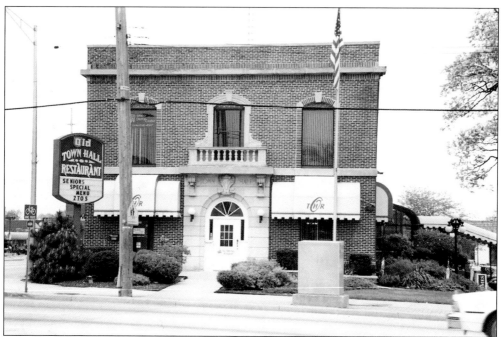

Having sat empty for years, the old town hall was purchased by a group of restaurateurs and carefully restored to reflect its architectural heritage. Opened as a family restaurant in 1987 and decorated with pictures of Munster's past, the name appropriately given to the eatery is The Old Town Hall Restaurant. (Photo courtesy of the Munster Historical Society.)

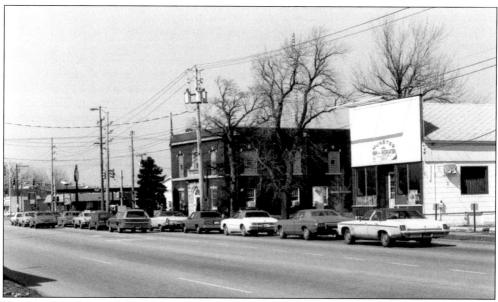

Prior to the construction of the new municipal center, the old Munster General Store was used by the town to house the Munster Parks and Recreation Department's offices. Having previously been a children's arcade and a used car sales office, the building sat empty until 1986 when it was dismantled and removed prior to the sale of the property. (Photo courtesy of the Munster Historical Society.)

With the closure of Lanier school in 1980 and property on the ridge becoming scarce, a plan was conceived in 1983 to construct a fine arts facility on the abandoned site. By 1987, ground had been broken for a $6 million, 70,000 square foot building, designed to house a 370-seat theater, two art galleries, a rehearsal hall for the Northwest Indiana Symphony, banquet facilities, classrooms, meeting halls, and the offices of the Munster Chamber of Commerce. When completed in 1989, the facility, located at 1040 Ridge Road, was aptly named the Visual and Performing Arts Center. (Photo courtesy of the Munster Historical Society.)

In 1968, Helen Kaske Bieker, the granddaughter of Johann and Wilhelmina Stallbohm, sold 32 acres of land on the southwest corner of Columbia Avenue and Ridge Road to the school system of the Town of Munster. As part of that sale, the Munster Parks Department took ownership of 6.5 acres for the development of Bieker Woods. In the early 1980s, Mrs. Bieker sold 2 acres of property along Columbia Avenue to St. Paul's Episcopal Church. Mrs. Bieker sold the 11 acres of land, the house she was living in, and the barn behind it, located on the southeast corner of Columbia Avenue and Ridge Road, to the Munster Parks Department in 1986. In 1995, the property was named Heritage Park in honor of its historical significance. (Photo courtesy of the Munster Historical Society.)

# Six

# Commuter Community

## 1990–Today

Advertised as only 30 miles from the heart of Chicago, the Town of Munster has been transformed into a community which allows its residents the opportunity to participate in the benefits of a big city, yet retains the charm associated with a small town. Visiting celebrities and hometown heroes, such as Hal Morris, a World Series first baseman, or Sue Hendrickson, the adventurer that discovered "Sue," the T-Rex displayed at the Field Museum in Chicago, can occasionally be seen dining at local eateries.

The town has spent millions of dollars beautifying the roadways and constructing recreational bike paths. With a population of just over 20,000, the Town of Munster maintains over 200 acres of park land in 20 parks spread throughout the community and has recently begun the process of planning for the development of a significant park in southern Munster.

Throughout the 1990s and into the new millennium, housing developments have continued to blossom south of 45th Avenue. Where farms once stood, upscale subdivisions by the names of Twin Creek, Cobblestones, Briar Creek, Somerset, White Oak Estates, and West Lakes have risen. A new concept in residential living for seniors called Hartsfield Village has also joined the community, as well as a number of luxury townhouse developments designed for those seeking a "no maintenance" lifestyle.

With 350 doctors having offices in Munster and 500 doctors now affiliated with Community Hospital, the Town of Munster has become one of Indiana's most affluent communities. Over 45 percent of the working population is employed in professional occupations and the average price of a home is close to $200,000. Starting in the early 1990s and continuing today, the school system has undertaken the remodeling or reconstruction of every major school facility. Named one of the top 250 schools in the nation and one of the top 10 in the state, Munster High School graduates an extremely high number of promising college bound students.

Although little evidence remains today of the early Dutch settlers, the Town of Munster has continued to maintain the pride, integrity, and beliefs that it was founded on.

With the development of the 127 lot Somerset subdivision in 1990 and faced with an increasing tax load, the Herr family, owners of Herr Farms, sold their final 20 acres of farm land. Located along White Oak Avenue, the land had been in the Herr family for eight decades and contained the town's last operating farm stand. (Photo courtesy of the Munster Historical Society.)

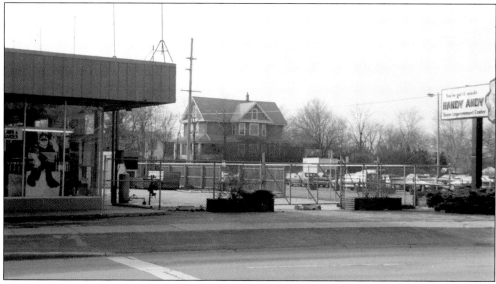

On the evening of September 28, 1994, George and Judy Gustafson, dining across the street, saw a plume of smoke beginning to rise from the Handy Andy Store at 330 Ridge Road. An alarm was immediately sounded, but before it was over nine communities had assisted in fighting a fire that eventually destroyed what once had been the Munster Lumber Company. (Photo courtesy of the Munster Historical Society.)

As Community Hospital continued to expand and add services, a location on the corner of Sheffield Avenue and Calumet Avenue was selected for their newest venture—a state of the art $14 million physical therapy facility. Named Fitness Pointe, it incorporated restorative therapy with preventive therapy in a health club environment and opened in October of 1998. (Photo courtesy of the Munster Historical Society.)

After a slow start, the development of the West Lakes Subdivision in the late 1990s brought with it the introduction of new housing to the southwest corner of Munster. (Photo courtesy of the Munster Historical Society.)

In a unique move, the Town of Munster instituted an economic development plan that allowed businesses an opportunity to receive tax incentives for the placement of community works of art. An example of this is the stainless structure by John Kearney, placed by Staley General Transportation in front of their facility along 45th Avenue on June 1, 2000. (Photo courtesy of the Munster Historical Society.)

Dedicated on June 26, 1999, this 24-foot Gazebo in Heritage Park has become a popular wedding spot. Seen above are Rocko and Crystal Graham being married by Town Clerk Dave Shafer. (Photo courtesy of the Munster Historical Society.)

Sadly, on the evening of May 15, 2002, the historic Stallbohm Barn burned to the ground. Built in the late 1800s and listed on the National Register of Historic Places, it was visited annually by scores of school children and adults alike. Despite a ruling of arson by a state Fire Marshall Investigator, and offers of numerous rewards, the barns destruction remains a mystery. (Photo courtesy of the Munster Historical Society.)

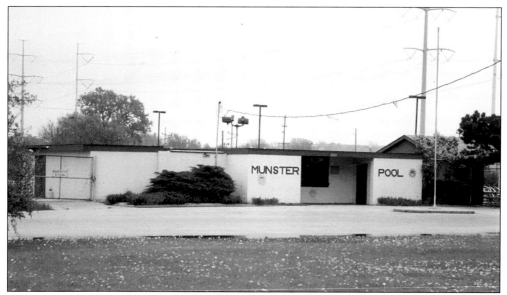

Having served the community for 45 years, the Munster Pool, operated by the Munster Pool Corporation, closed in the fall of 2001. However, under the leadership of Chuck Gardiner, the Munster Parks Department spearheaded the construction of a new water recreation facility that opened to waiting crowds in 2002. (Photo courtesy of the Munster Historical Society.)

Known as "Big Red" the Munster Fire Departments Snorkel Truck became famous in 1999 when it was used as the model for the Franklin Mint's replicas. The unit was originally purchased for $95,000 in 1972 and can be seen above with Fire Chief Robert C. Nowaczyk and members of the 2003 department. (Photo courtesy of the Munster Historical Society.)

In 1981, the Munster Police Department organized a motorcycle patrol unit with three patrolman, including Officer Robert Grove. Killed in 1983 in the line of duty, Officer Grove was honored in May of 2003 when Ridgeway Park was renamed in his memory to Grove Park. (Photo courtesy of the Munster Historical Society.)

Chartered in November of 1988, the Munster Veterans of Foreign Wars Post 2697 has honored the memories of fallen soldiers buried in the Munster Christian Church cemetery since 1990. In addition, the members of the post have been actively involved in the development of the Community Veterans Memorial, which was dedicated on June 1, 2003 on the corner of Sheffield and Calumet Avenues. (Photo courtesy of the Munster Historical Society.)

The 2003 Munster Town Council is strongly represented by (back row) Dave Shafer (Clerk-Treasurer), Steve Pestikas, David Nellans, John Hluska, and Helen Brown. The Town of Munster's professional management team includes (front row) Matt Fritz (Assistant Town Manager), Tom DeGiulio (Town Manager), and Eugene Feingold (Town Attorney).

# Epilogue

History is created daily! For those interested in seeing it, it might be in the opening of a business, the vote of a town council member, the siren of an emergency vehicle, or the graduation of a student. What does history tells us about the future of the Town of Munster? The answer lies within each of the town's residents and the officials elected by their votes. It is no coincidence that the Town of Munster developed in the way that it did. Starting in 1935, the elected officials of the Town of Munster began to plan unselfishly for the future. Originally called the town's "Master Plan" it was first documented in 1938 and was represented as a map showing residents what the town would look like when Munster's farm land was fully developed. Throughout the years, the plan has evolved into a series of paper documents which have allowed for the development of business districts, the mapping of residential subdivisions, the definition of construction codes, the size and placement of schools, the nurturing of parks and recreation areas, and the implementation of numerous community services.

Today, the Town of Munster is recognized throughout the area as a safe, well-managed community with an excellent school system. Most residents enjoy an exceptionally high quality of life and are pleased with their elected officials. The plans under development for the town's future include the continued commercial development of southern Munster, the beautification and expansion of the town's major throughways, the growth and beautification of park properties, the implementation of new technologies into the town's administrative offices, police and fire response systems, and a continued investment in the highest quality of education available. Furthermore, town officials have mandated efforts targeted at the development of relationships and the sharing of knowledge between the town, the community, civic and social groups, and local businesses. These efforts, coupled with the involvement of local residents, and an insightful plan, as offered by the town's gifted officials, tend to lead one to believe that the future history of the Town of Munster will be a bright one.

On July 4th 1989, The Munster Historical Society, in conjunction with the Town of Munster, placed a time capsule on the grounds of the Visual and Performing Arts Center. Scheduled to remain closed until the year 2076, the capsule was dedicated to those individuals that valued the importance of history while also contributing to the traditions that allow for the Town of Munster to continue prospering. Although the content of the six-foot cubic box remains a mystery, it is known that many unique and significant items were placed inside. (Photo courtesy of the Munster Historical Society.)

# AERIAL VIEWS OF THE TOWN OF MUNSTER

Throughout the history of Munster, various departments within the town's municipal organizations have used aerial views. Principally deployed in the planning of roadways, water lines, and the placement of the town's municipal infrastructure, these images offer an insightful and an enlightening view of the town's development. By contrasting one image after another, as presented in the following pages, the reader has an opportunity to visually experience the rapid development of the town over a 50-year period starting in 1949. For those interested in satellite images of the town or even an image of a single piece of property located within the town, generally available photos may be found by searching the Internet using a keyword phrase such as "Aerial Map or Satellite Photo" and accessing the web site(s) identified.

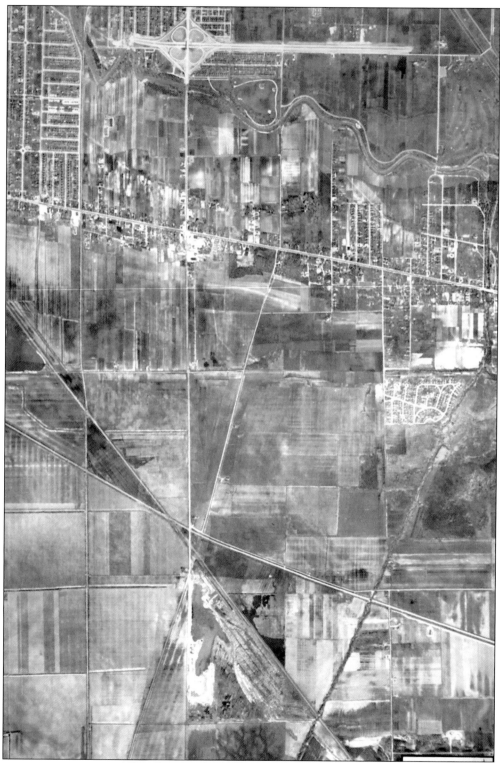
Aerial View of the Town of Munster in 1949.

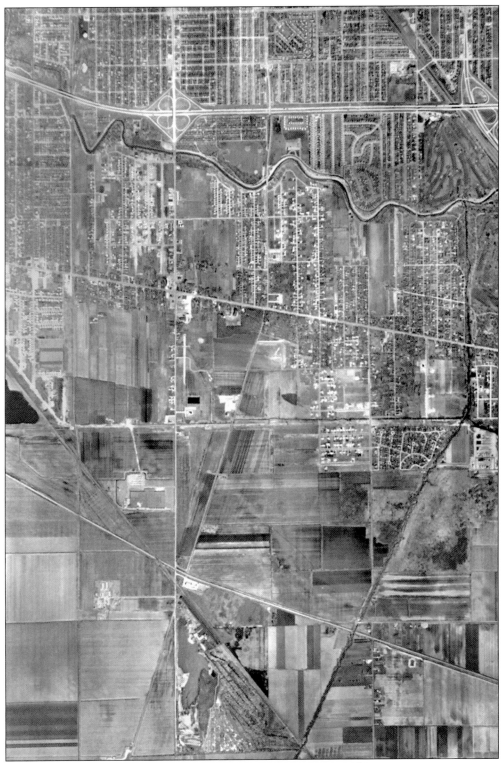
Aerial View of the Town of Munster in 1959.

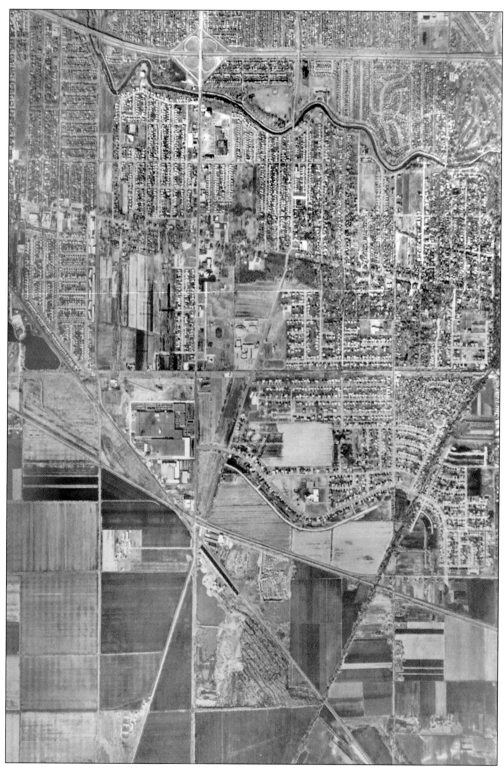
Aerial View of the Town of Munster in 1968.

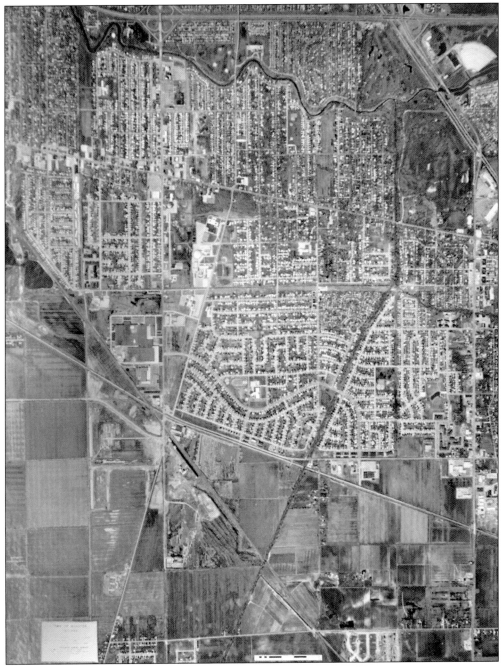
Aerial View of the Town of Munster in 1977.

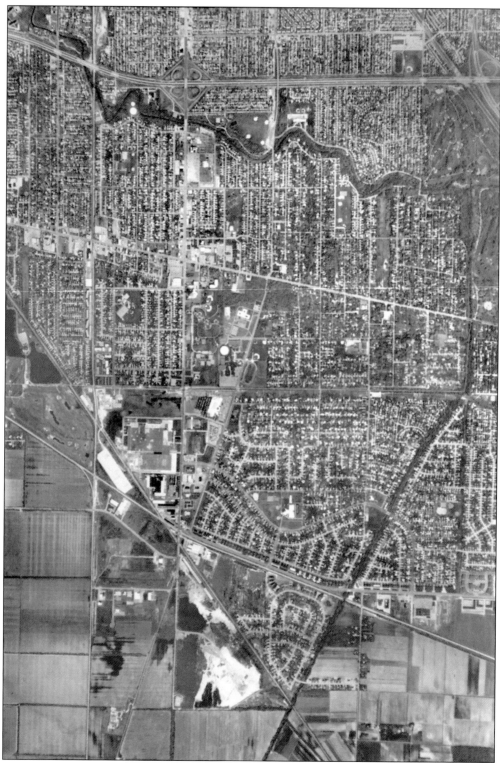
Aerial View of the Town of Munster in 1987.

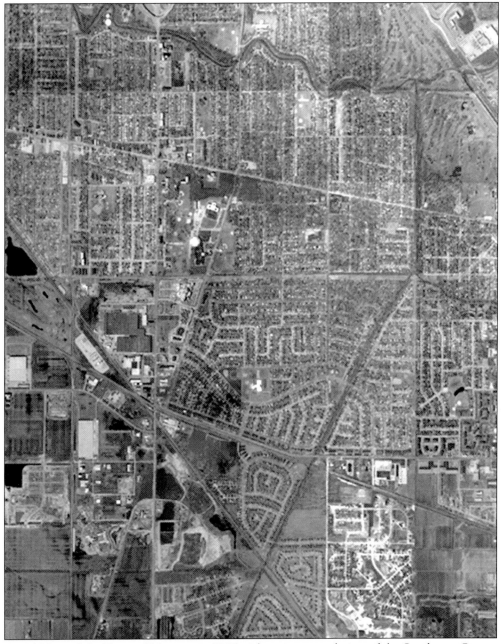
Aerial View of the Town of Munster in 1995 with an integrated view of the Southwest Corner updated in 1997.

# References

**Centennial of the First Christian Reformed Church, Munster Indiana**
1970, The Munster Centennial Committee

**Community Housing Survey**
1970, The Munster League of Women Voters

**Early History of the Calumet Region**
1935, Harry Eenigenburg

**Hammond Historical Society Archives, History of Lake County**
1934, A. Demmon, J. Little, P. McNay, and A. Taylor

**Munster Historical Society Archives**

**Newspaper Publications**:
  *Munster Sun Journal* (Various Editions)
  *Sun Journal* (Various Editions)
  *The Hammond Times* (Various Editions)
  *The Lake County Times* (Various Editions)
  *The Times* (Various Editions)

**The Calumet Region: Indiana's Last Frontier**
1959, Powell Moore

**The Town on the Ridge**
1982, Lance Trusty

# Acknowledgments

**Galaxy Arts**:
233 Ridge Road, Munster, Indiana, 46321, www.galaxyarts.com
For Photo Reproduction, Restoration, Preservation, and Framing Services,
as well as Digital Photography, Formatting, and Printing Services.

*If you would like Quality Framed Reproductions of the Images in this Book, Please Contact Galaxy Arts at (219) 836-6033*